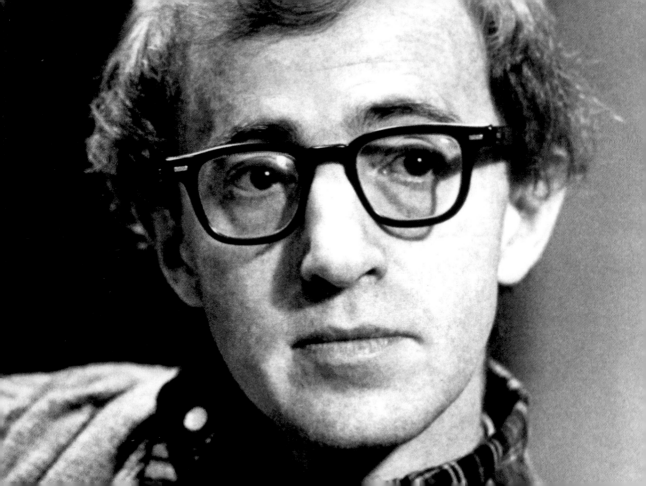

Woody Allen

Woody Allen

A PHOTOGRAPHIC CELEBRATION

edited by Ward Calhoun

Skyhorse Publishing

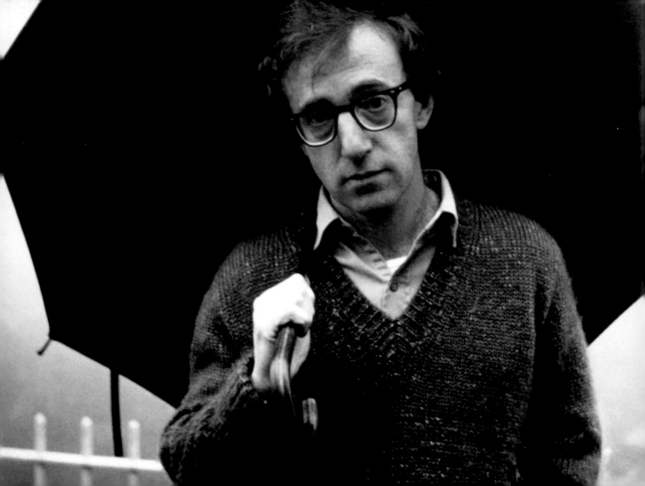

"Life is full of misery, loneliness, and suffering—
and it's all over much too soon."
—WOODY ALLEN

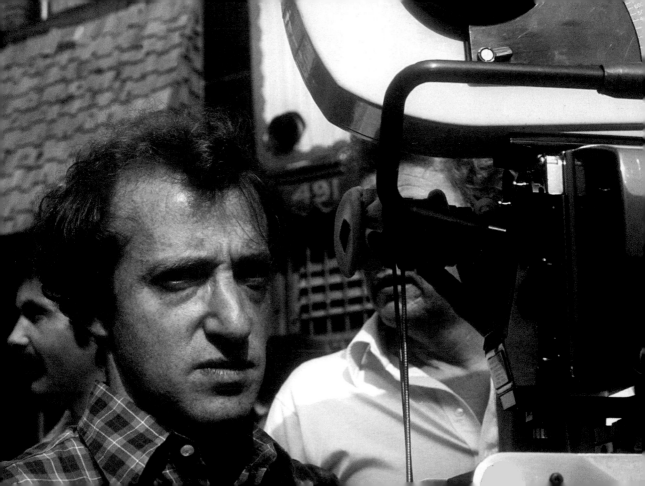

"My mother always said I was a very cheerful kid
until I was five years old,
and then I turned gloomy."
—WOODY ALLEN

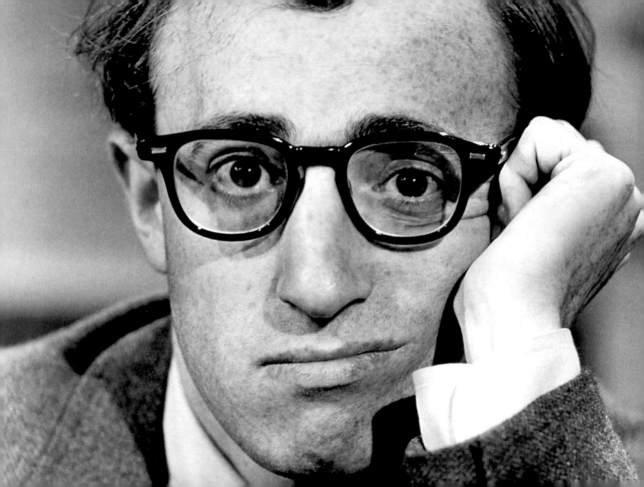

Woody Allen was born Allan Stewart Konigsberg in Brooklyn, New York on December 1, 1935. "With his carroty hair, big ears, and milky skin, he looked just like his mother," wrote biographer Marion Meade.

Allen's father worked as a cab driver, jewelry engraver, and a waiter, among other things. His mother was a bookkeeper for a Manhattan florist. His sister, Letty, was born when Woody was eight. His parents hoped he would become a pharmacist.

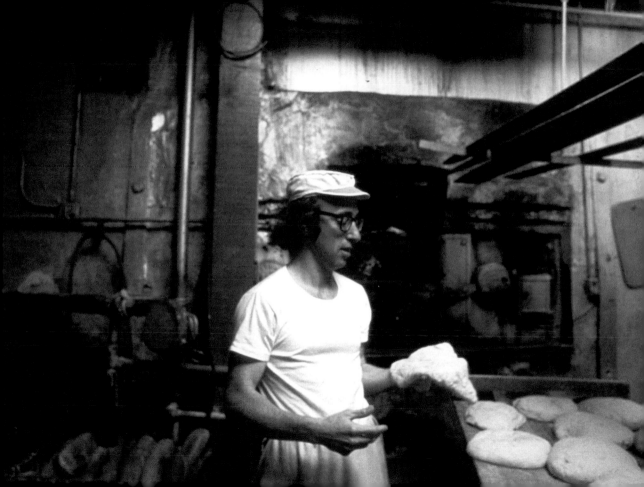

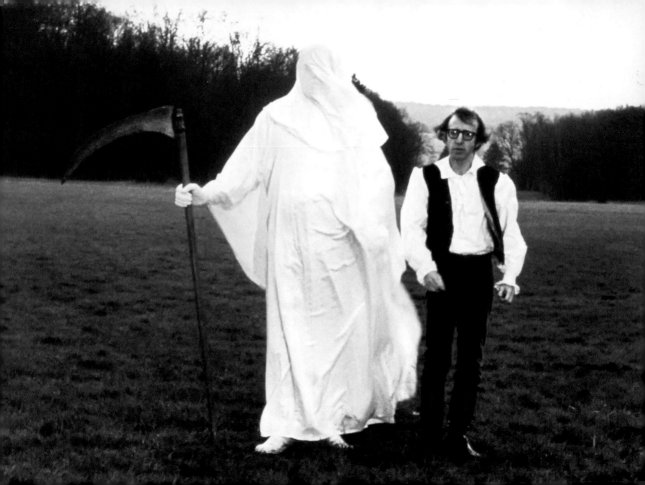

"My mother is an orthodox paranoid and,
while she doesn't believe in an afterlife,
she doesn't believe in a present one either."
—WOODY ALLEN

"Woody Allen knows exactly what he wants. It's always been his particular strength to push the independent ideal as far as it will go, and he gets away with it because his writing is so extraordinary. He's the living proof that talent will out."
—Chiwetel Ejiofor

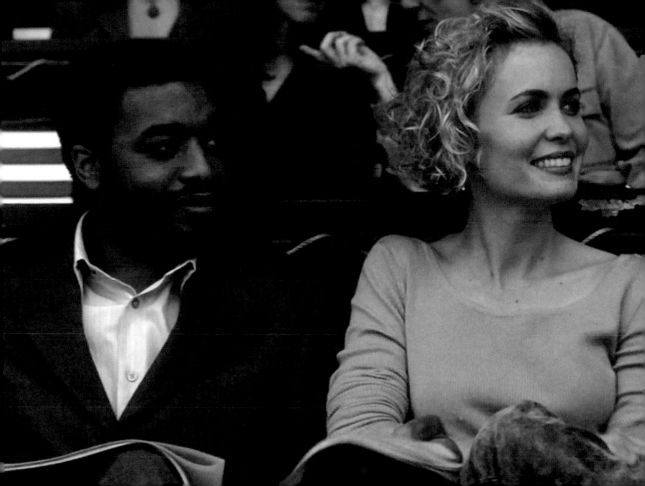

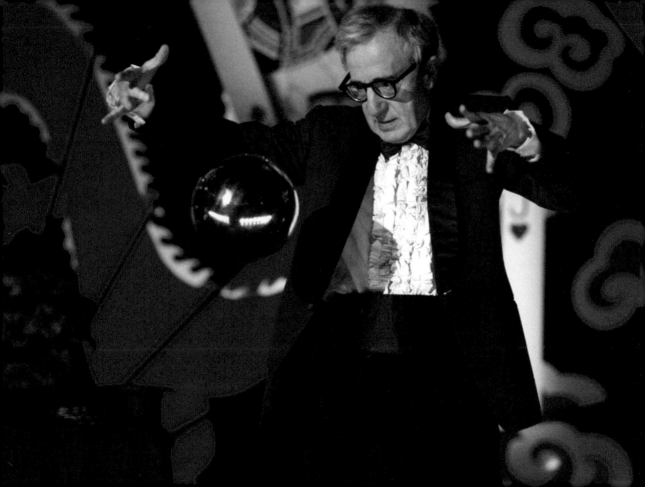

Allen regaled fellow students at Midwood High School with his extraordinary knowledge of magic and card tricks, which later played a part in such films as *Curse of the Jade Scorpion* (2001) and *Scoop* (2006).

"They say Allen got something
from the Marx Brothers.
He didn't. He's an original.
The best. The funniest."
—Groucho Marx

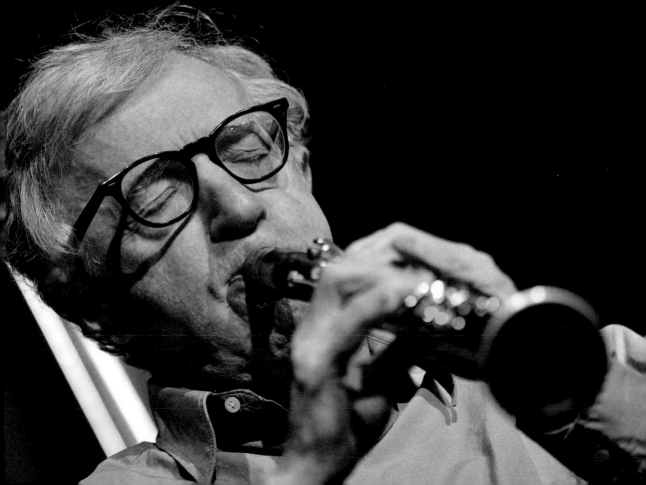

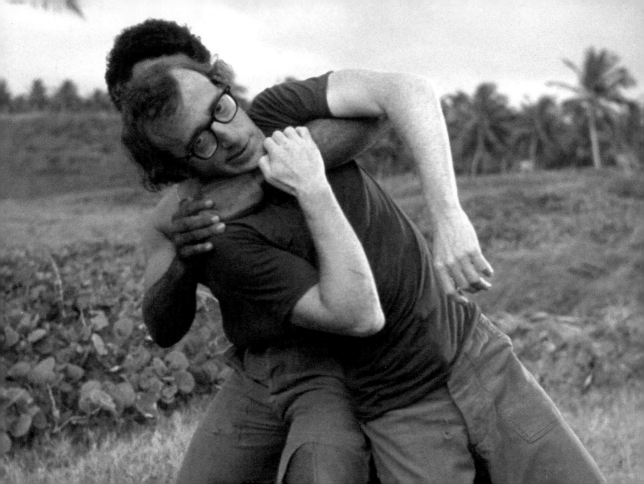

"I had infantile interests. You'd be remarkably surprised.
I wanted to be a cowboy. I wanted to be a private detective.
These were the things that were on my mind at the time.
I had no substantial interests whatsoever."
—WOODY ALLEN, ON HIS TEENAGE ASPIRATIONS

At the age of fifteen, Allen began writing his own jokes and mailing them to various New York newspapers. His moxie paid off and soon his gags were getting picked up by columnists with his name appearing alongside his material.

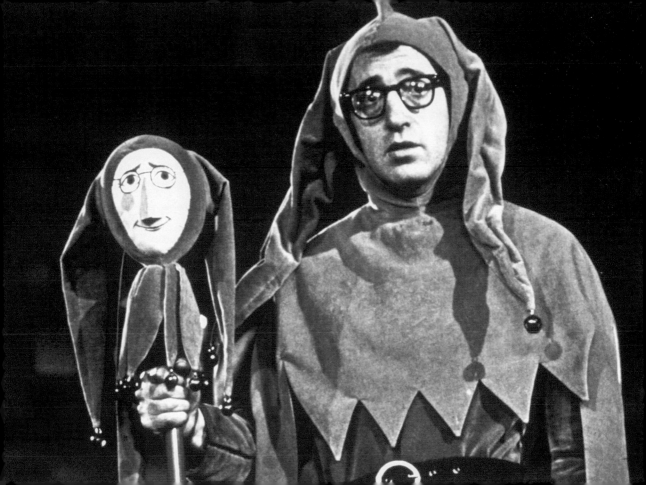

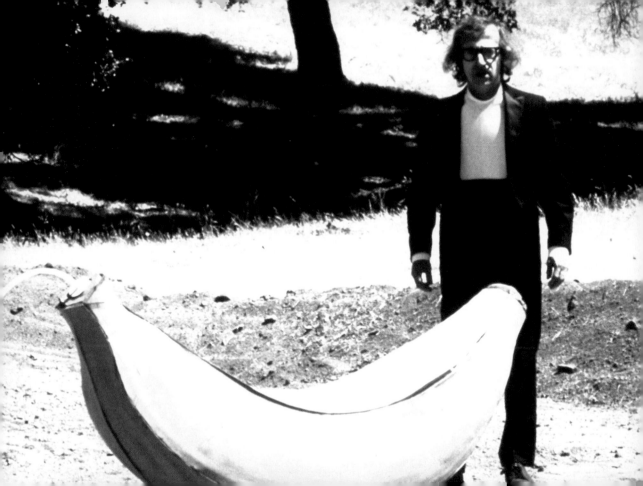

"It takes no tarot deck to foresee a day, thirty years hence,
when the last surviving movie theaters
will be mounting Woody Allen festivals containing hours
of the best sight and sound gags of the epoch."
— *TIME* MAGAZINE, 1972

"I am thankful for laughter, except
when milk comes out of my nose."
—WOODY ALLEN

Still a teenager, Allen was hired by press agent David O. Alber as a joke writer. He made $25.00 a week writing gags and one-liners that were credited to various celebrities in newspaper gossip columns.

"Money is better than poverty,
if only for financial reasons."
—WOODY ALLEN

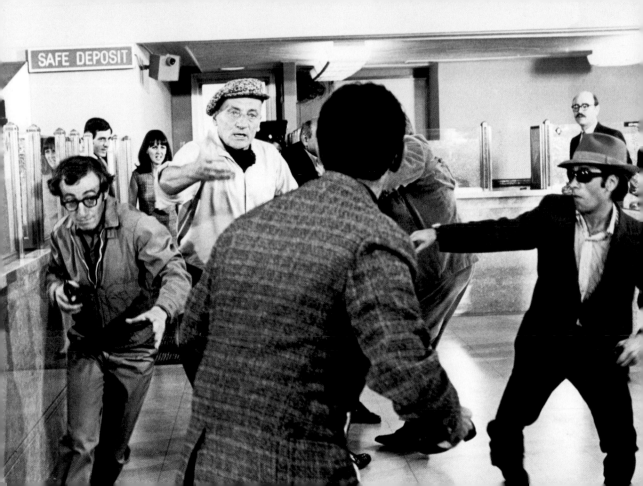

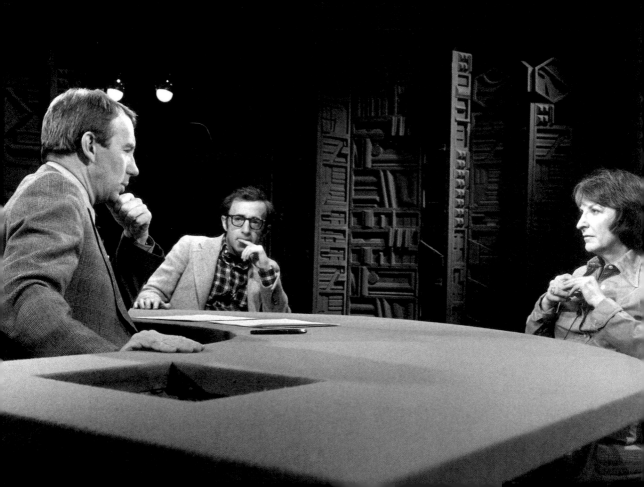

"Woody Allen appears before us as the battered adolescent, scarred forever, a little too nice and much too threatened to allow himself to be aggressive. He has the city-wise effrontery of a shrimp who began by using language to protect himself and then discovered that language has a life of its own."
—PAULINE KAEL

"Before I could read, I'd always wanted to write."
—WOODY ALLEN, ON BEING ASKED
WHEN HE STARTED WRITING

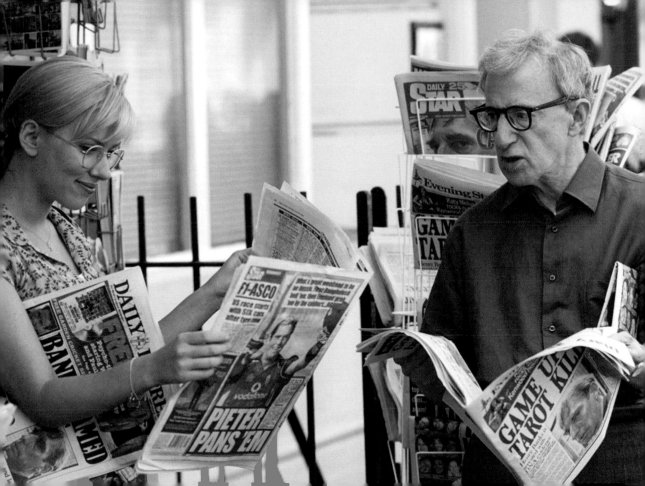

Allen eventually graduated to writing bits for comedian
Herb Shriner (for $75.00 a week), actor Art Carney,
crooner Pat Boone, and television personality Garry Moore.

"80% of success is showing up."
—Woody Allen

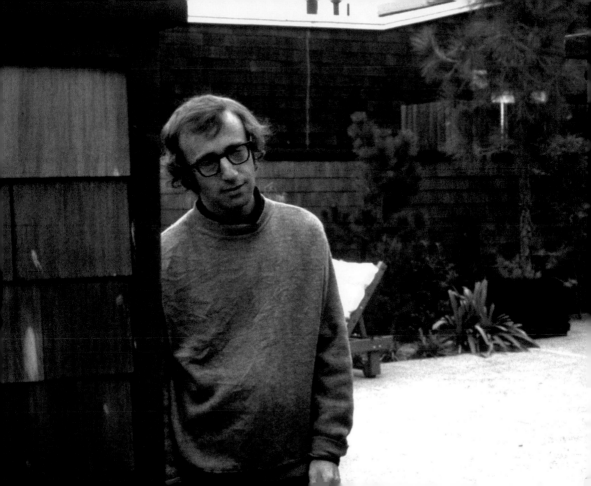

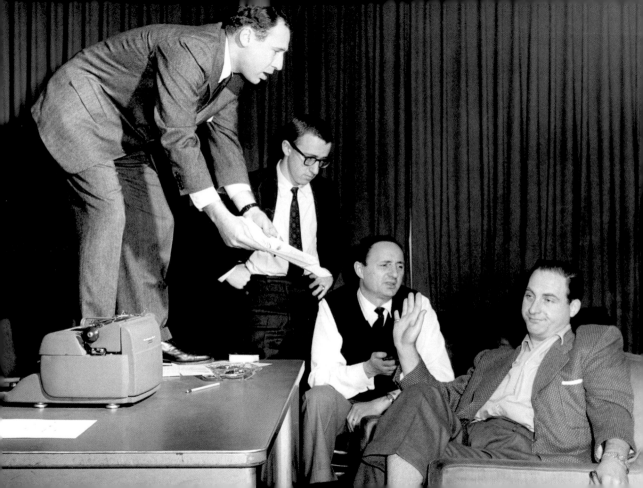

Allen's big break came at age nineteen, when an agent
with William Morris hired him at NBC, where he met
Danny Simon (brother of playwright Neil), with whom
he wrote for comedian Sid Caesar alongside fellow
comedy legends Mel Brooks, Carl Reiner,
and Larry Gelbart. His weekly salary: a princely $1,500
—not bad for a nineteen-year-old.

"For Sid you didn't write jokes so much, you wrote . . . funny, real situations. There weren't 'jokes,' in the conventional sense, 'cause he was not a conventional teller of one-liners."
—WOODY ALLEN, ON WRITING FOR SID CAESAR

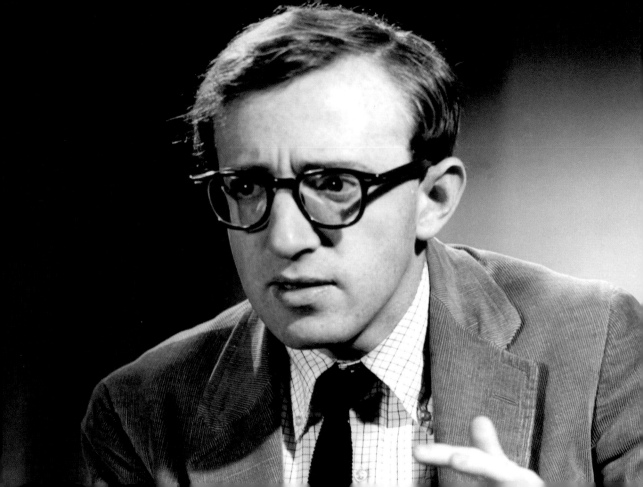

Allen and Larry Gelbart wrote a 1960 TV special,
Hooray for Love, for Art Carney. It included a film parody,
"Strange Strawberries," directed by alleged Scandinavian art-house
sensation "Ingmar Birdman." The cast included Carney,
Tony Randall, and Janis Paige.

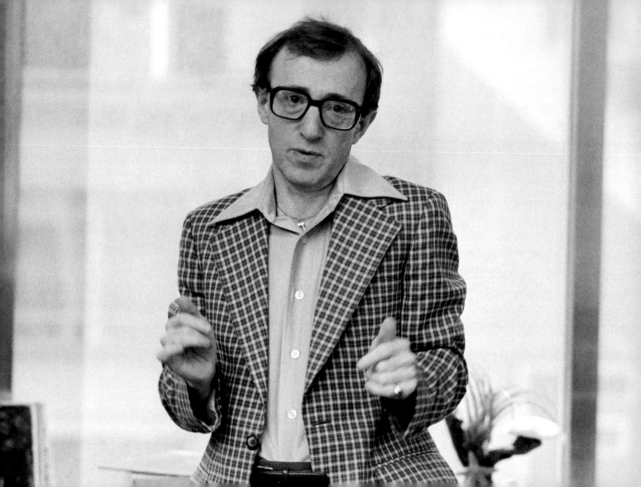

"Life doesn't imitate art,
it imitates bad television."
—WOODY ALLEN

"He knew zero about the art of performing and bringing the material on a nice silver platter to the audience."
—JACK ROLLINS, ON WOODY ALLEN'S
EARLY ATTEMPTS AT STAND-UP COMEDY

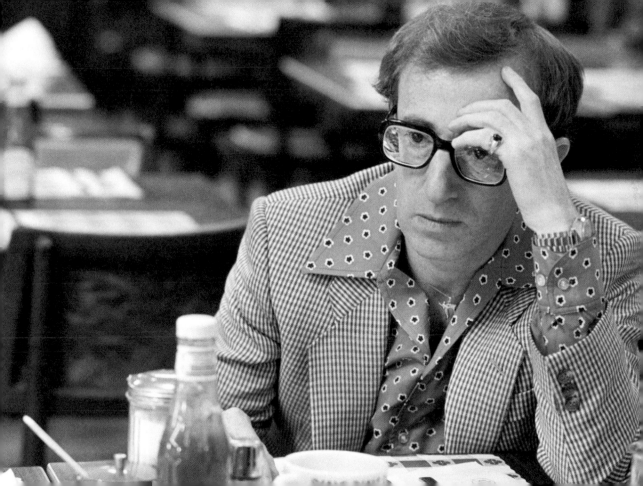

Inspired by new-wave comedian Mort Sahl, Allen
made his stand-up debut in 1961 at the Duplex
in New York City's Greenwich Village.

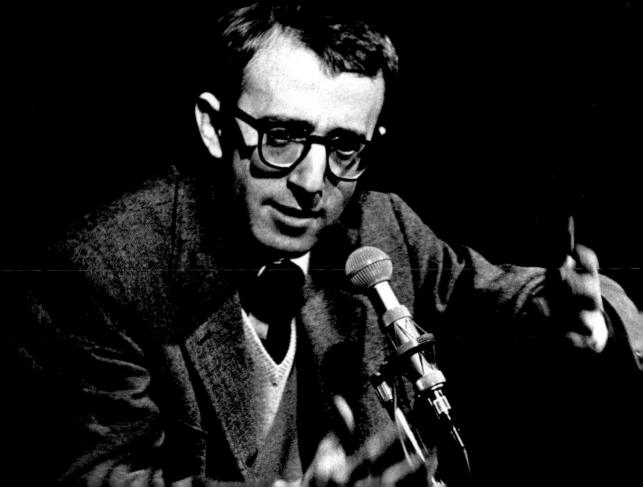

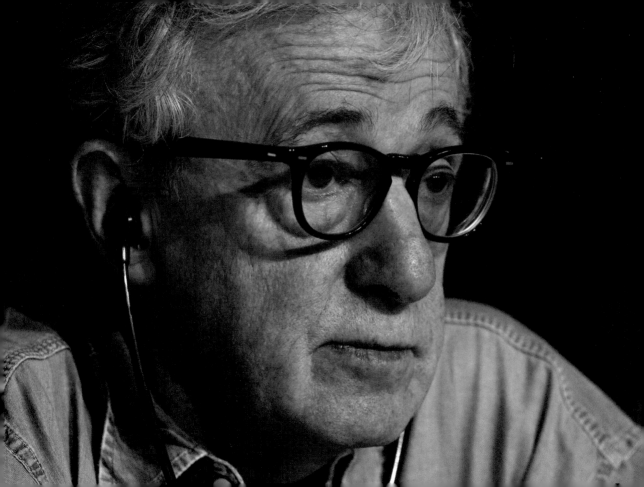

"I just wrote the jokes and told them and as I gained a little strength as a comedian, as I got a little practice getting up there and sort of projecting, keeping the energy up and enjoying it, it began to work for me. It's hard enough writing good jokes, much less tailoring them to the audience. But if a joke doesn't get a laugh, I take it out right away."
—WOODY ALLEN

"I can levitate birds. No one cares."
—WOODY ALLEN

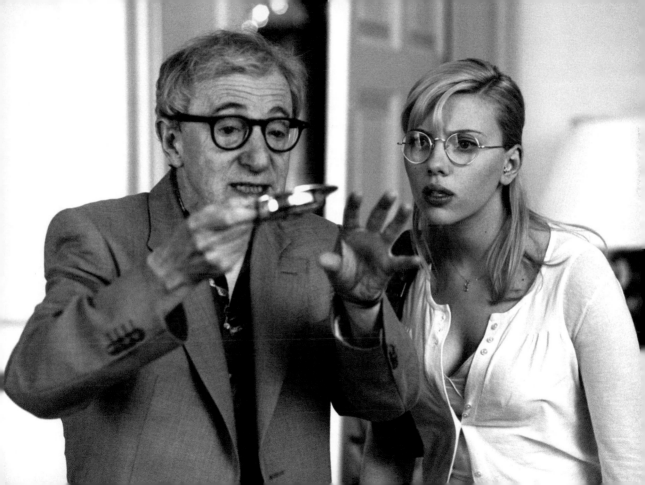

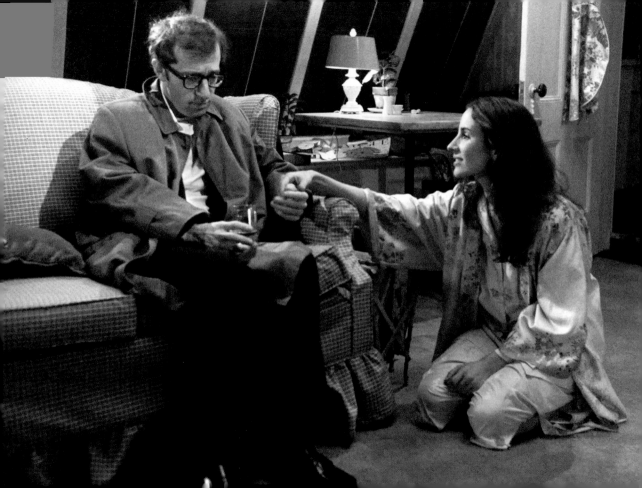

"I'm not a drinker, my body won't tolerate spirits, really. I had two martinis New Years Eve and I tried to hijack an elevator and fly it to Cuba."
—WOODY ALLEN

A typical '60s Allen gambit involved using a comic inversion, or "switch": for example, Allen said he carried a sword on the street—in case of an attack it turned into a cane, so people would feel sorry for him. He did this so often his fellow comedians began calling him "Allen Woody."

"One night, after about twelve gems in a row had gone by
the audience who sat there blinking stupidly at the lights,
he just came to a complete stop. There was an awful long moment
where nobody knew if he was going to go on or what.
Then he just said, 'If I were giving prizes for the
worst audience I've ever seen, you'd win it.'"
—DICK CAVETT, ON AN EARLY ALLEN STAND-UP PERFORMANCE

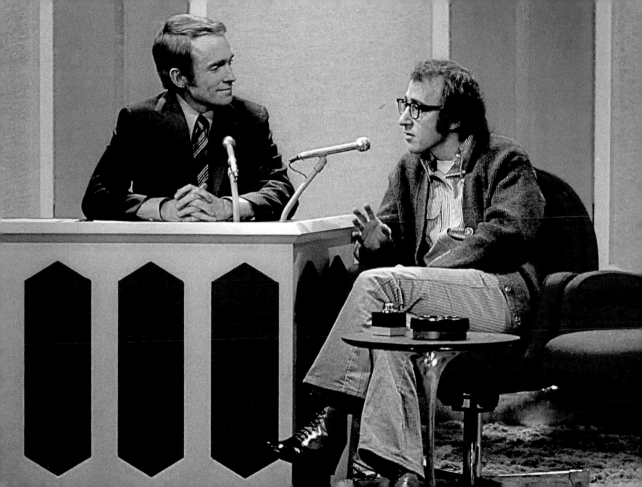

1965 saw the release of Allen's first feature-film screenplay, *What's New Pussycat?* The sex farce, which began as a vehicle for Warren Beatty, eventually starred Peter O'Toole and Peter Sellers, as well as Woody himself.

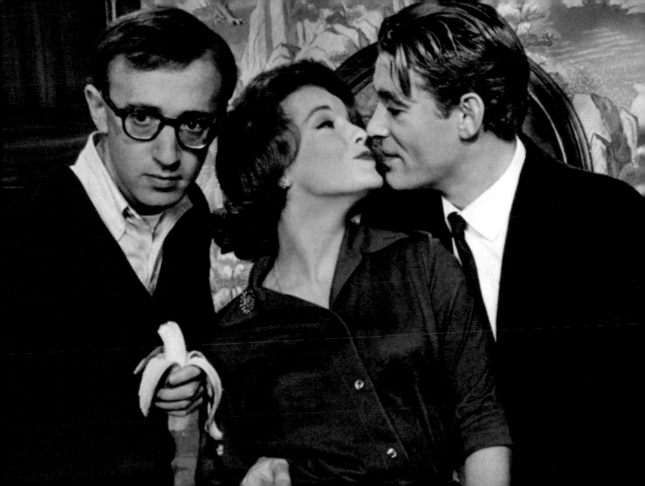

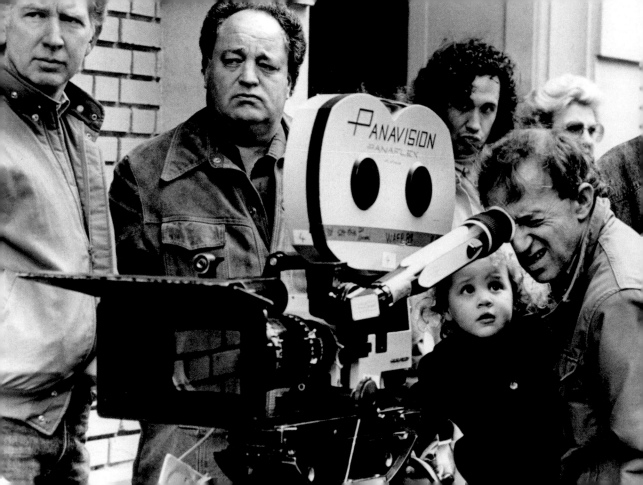

"I wrote my first script and the studio badgered me.
After that I felt I had to become a director.
In theatre, the writer is king.
Film doesn't work that way."
—WOODY ALLEN

"I was just a poor student. I had no interest in it.
When I make a film the tacit contract with the audience
is that I will give them some entertainment
and not bore them. I have to do that."
—WOODY ALLEN

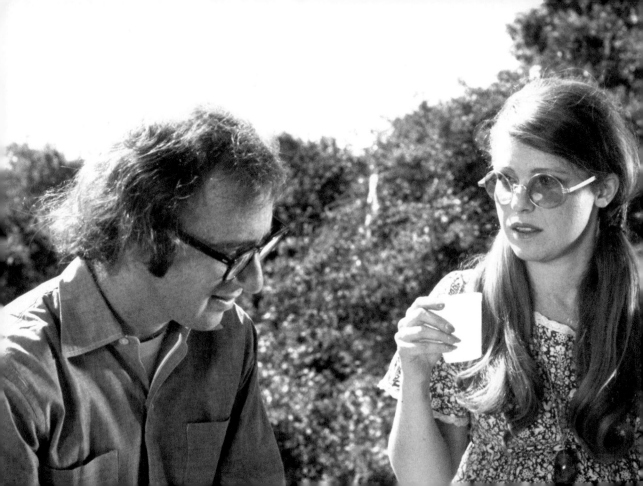

In 1966 Allen married Louise Lasser, who later starred
as the heroine of Norman Lear's mock television soap opera, *Mary
Hartman, Mary Hartman*. He was married
to his first wife, Harlene Rosen, from 1954–59.

"Considering how obsessed he is,
he was really terrific to live with."
—LOUISE LASSER

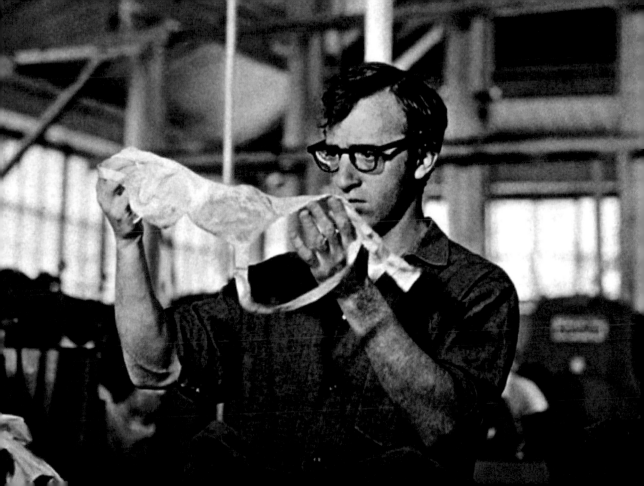

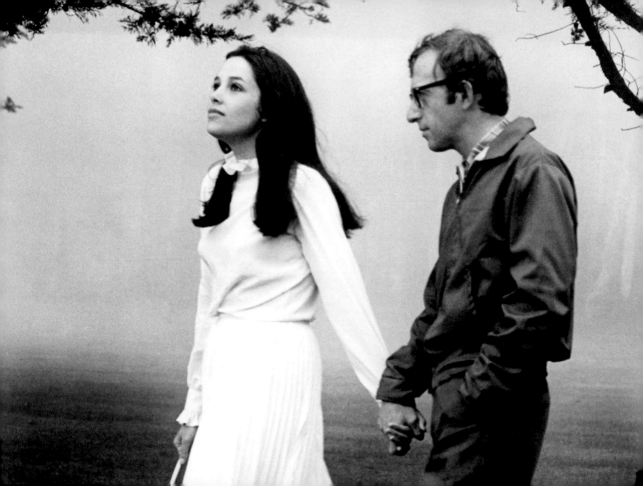

"I did not marry the first girl that I fell in love with, because there was a tremendous religious conflict, at the time. She was an atheist, and I was an agnostic."
—WOODY ALLEN

Allen became a successful Broadway playwright in 1966, with *Don't Drink the Water*. In the cast was his future *Annie Hall* costar, Tony Roberts.

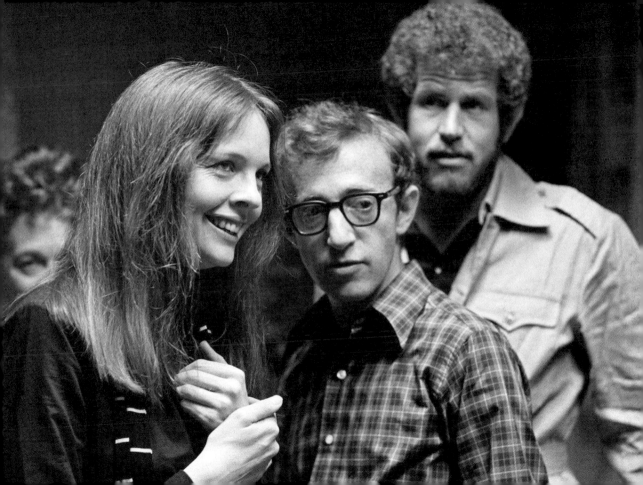

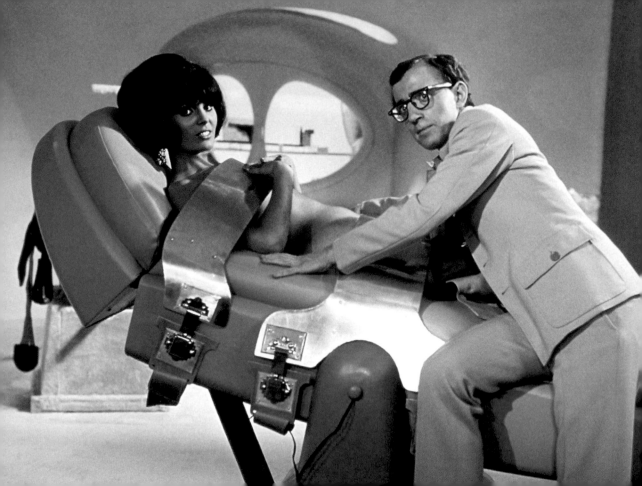

1967 saw the release of the James Bond send-up *Casino Royale*, a film Allen both acted in and cowrote. During the London shoot, Allen's final scene got delayed so many times that he reportedly left the set in full costume and flew back to New York.

"I think I would hate them."
—WOODY ALLEN, ON WHY HE NEVER
WATCHES ANY OF HIS OWN MOVIES

"My experience has been that writing for the different mediums are very separate undertakings. Writing for the stage is completely different from writing for film and both are completely different from writing prose."
—WOODY ALLEN

Allen wrote and appeared in two TV specials, which aired in 1968 and 1970. Guests included Teri Garr, Candice Bergen, Billy Graham, Liza Minnelli, and the Fifth Dimension.

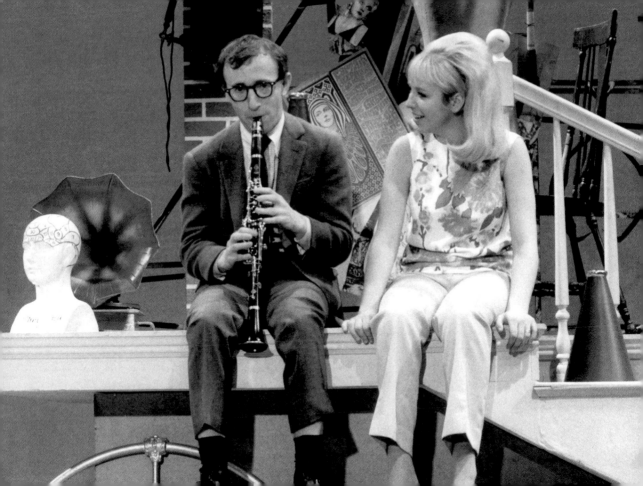

"It's not like a movie, where if it is a great film like *Paths of Glory* but no one goes to see it it still eventually becomes amortized and also passes into the literature of film."
—WOODY ALLEN, ON TELEVISION

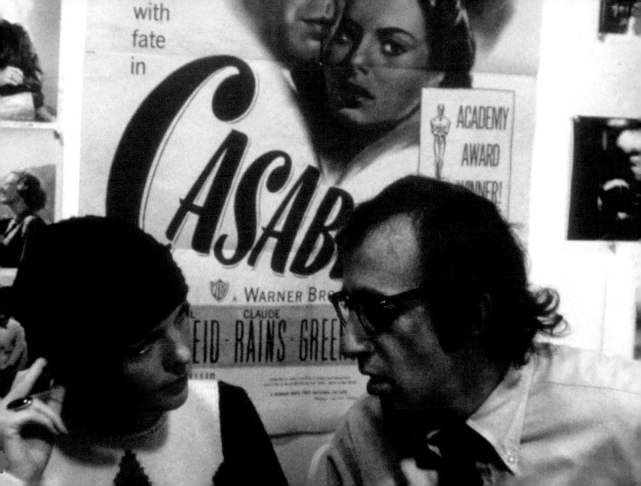

"Woody Allen . . . has the anesthetized face of a
Jewish Buster Keaton combined
with a sensible woman shopper's."
—PAULINE KAEL

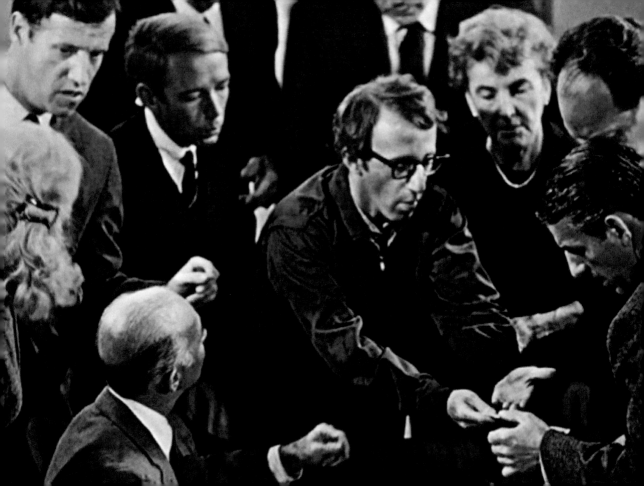

In 1969 Allen finally took the reins and settled into the role with which he would become accustomed: writing, directing, and starring in the slapstick crime comedy *Take the Money and Run*. In the film he played bumbling small-time hood Virgil Starkwell.

"The two biggest myths about me are that I'm an intellectual, because I wear these glasses, and that I'm an artist, because my films lose money. Those two myths have been prevalent for many years."
—WOODY ALLEN

"When you fall in love with somebody and marry them, are you all of a sudden going to stop loving them?"
—LOUISE LASSER, ON HER MARRIAGE TO WOODY ALLEN

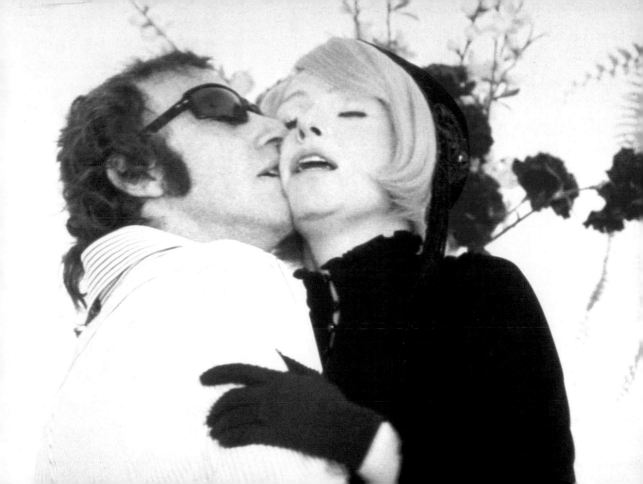

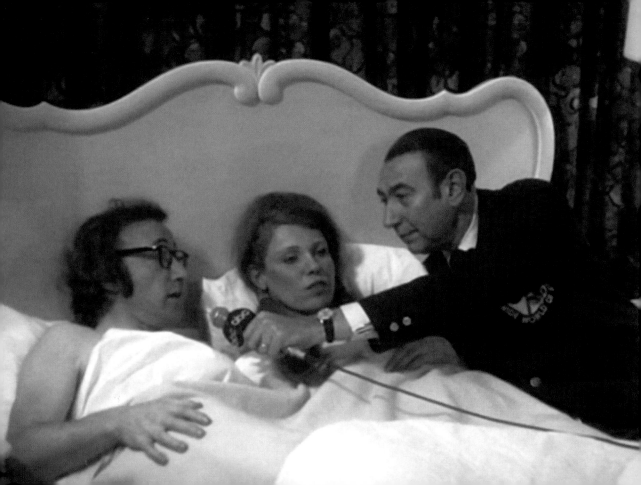

Though Lasser and Allen divorced in 1969, she still appeared opposite him in his next two movies, *Bananas* (1971) and 1972's *Everything You Always Wanted to Know About Sex* (*But Were Afraid to Ask)*. The former saw Woody joining a group of South American rebels in an attempt to win the heart of a girl in New York.

"Time is nature's way of keeping everything
from happening at once."
—Woody Allen

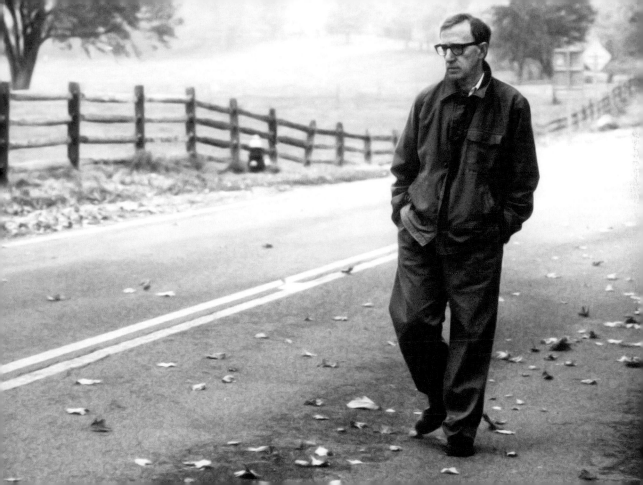

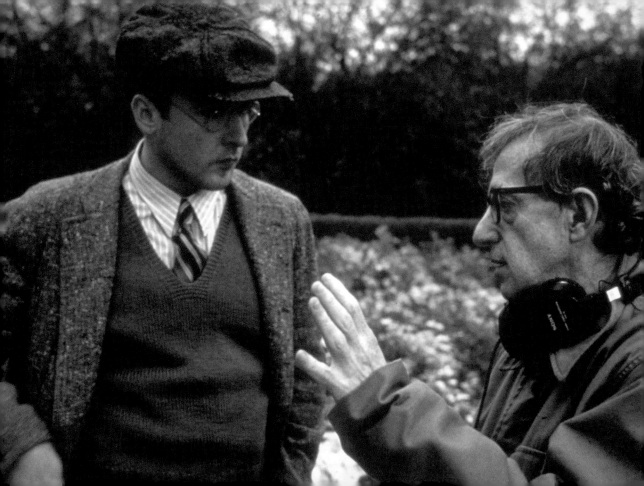

"I can't imagine that the business should be run any other way
than that the director has complete control of his films.
My situation may be unique, but that doesn't speak well for
the business—it shouldn't be unique, because the director is
the one who has the vision and he's the one
who should put that vision onto film."
—WOODY ALLEN, ON THE MOVIE BUSINESS

In 1972 Allen brought his successful Broadway play
Play it Again, Sam to the big screen. Though he starred
in the film adaptation, this time he left the directorial duties
to Herbert Ross, who went on to direct *The Turning Point* and
Footloose, among others.

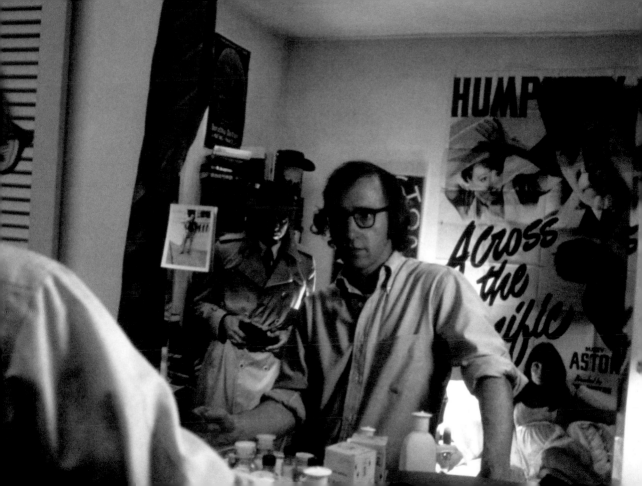

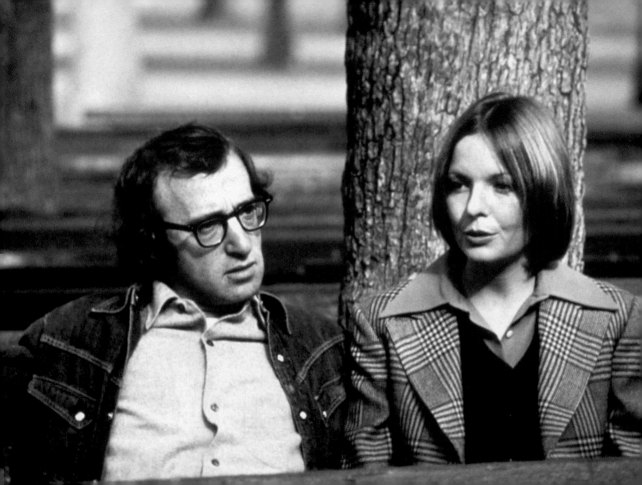

Play it Again, Sam also marked the start of Woody's on-screen partnership with actress Diane Keaton. The film, which was something of an homage to Humphrey Bogart and *Casablanca*, indeed proved to be the beginning of a beautiful friendship between Allen and Keaton.

"I had a huge crush on Woody right
from the moment I saw him."
—DIANE KEATON

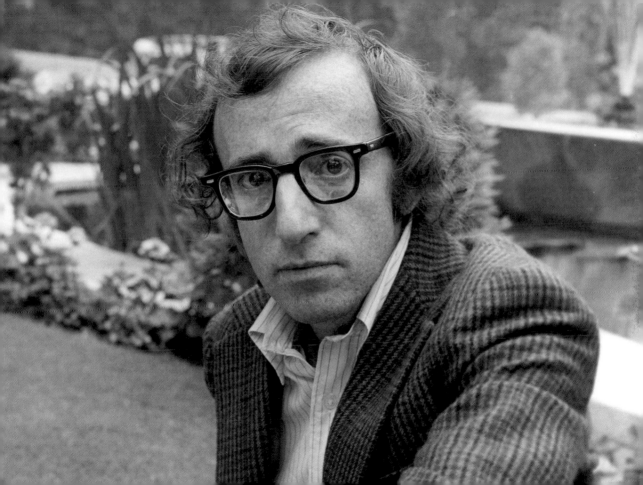

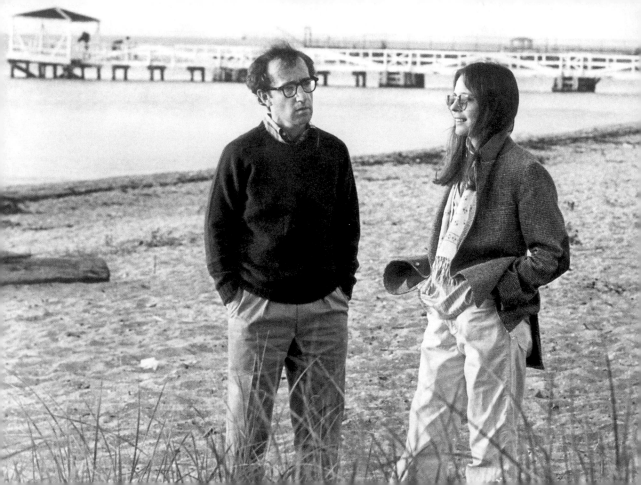

"I knew Diane very well. I had done a play with her,
Play It Again, Sam, we had lived together, and we were very close.
I just felt she had a limitless comic talent."
—Woody Allen

1973 marked the release of Allen's zany futuristic comedy *Sleeper*.
Wanting to make sure that his funny notions about America
in the twenty-second century had at least some toehold in reality,
Woody ran some of his concepts by noted
science-fiction author Isaac Asimov.

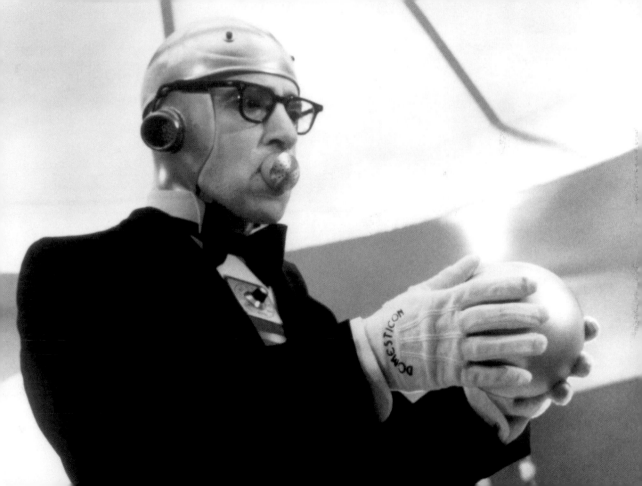

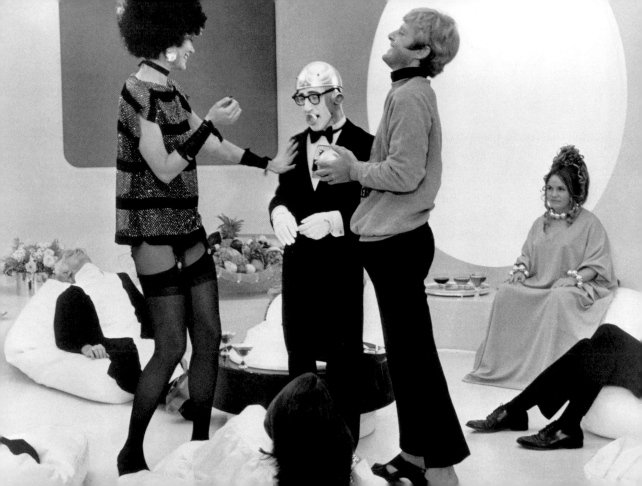

"Marshall Brickman and I wanted to write a movie that wasn't just gag-gag-gag. I was good at writing gags, but to write a story with a real plot and real characters—that was much harder."
—WOODY ALL EN, ON SLEEPER

"I just liked being his stupid sidekick. I loved it.
And she was such a jerk. I love jerks."
—DIANE KEATON, ON HER ROLE OPPOSITE ALLEN IN *SLEEPER*

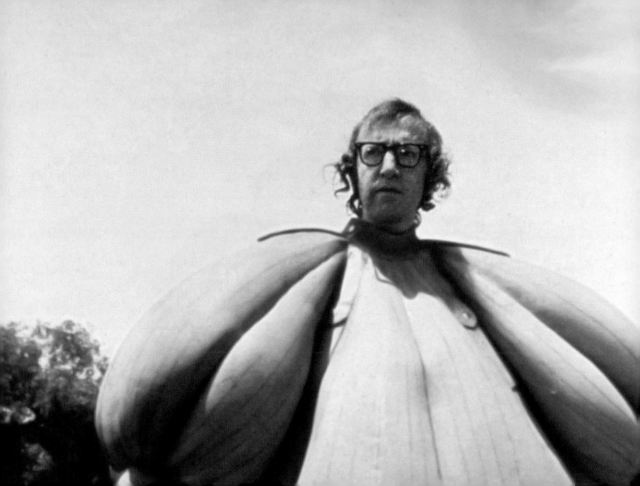

"I had a small budget, and I was working in the future,
so every car had to be built, every costume had to be designed.
Fortunately, my costume designer was Joel Schumacher.
He had, like, a $10,000 budget to do all the costumes,
but he was brilliant and inventive."
—WOODY ALLEN, ON *SLEEPER*

Allen followed up the space-age hijinks of *Sleeper* with *Love and Death* (1975), a comedy which drew its inspiration from the works of such Russian novelists as Tolstoy and Dostoevsky.

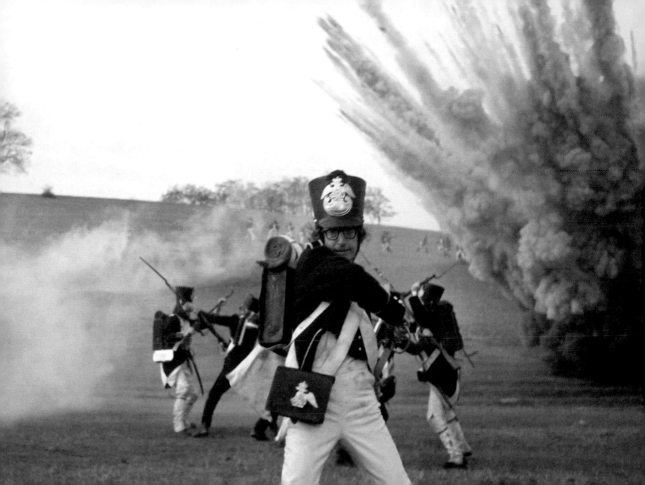

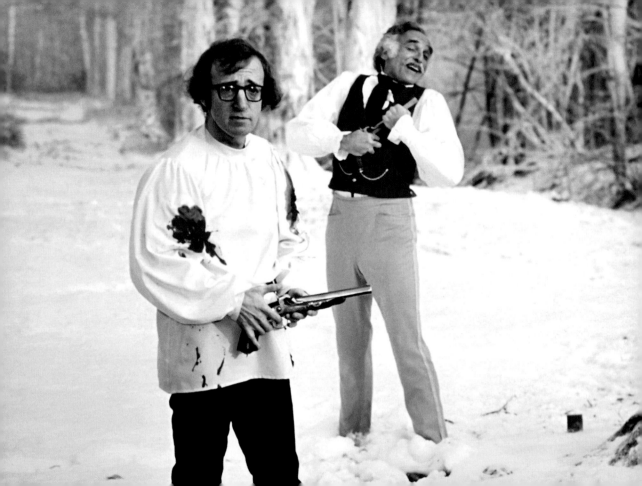

"I'm not afraid of dying . . . I just don't want
to be there when it happens."
—WOODY ALLEN

"There are worse things in life than death.
Have you ever spent an evening
with an insurance salesman?"
—WOODY ALLEN

"This year I'm a star, but what will I be next year? A black hole?"
—Woody Allen, in 1977

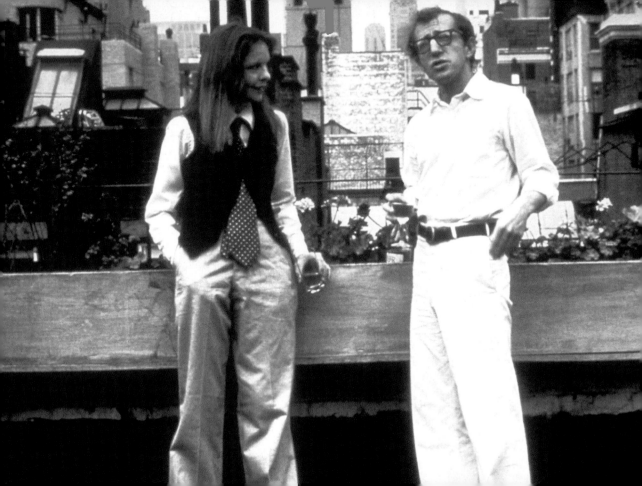

In terms of audience and film industry recognition, 1977's *Annie Hall* proved to be a high-water mark for Allen. The comedy, which many consider to be Woody's most personal film to date, won four Academy Awards including Best Actress (Diane Keaton), Best Original Screenplay (Allen and Marshall Brickman), Best Director (Allen), and Best Picture. In fact, no comedy has claimed Best Picture honors since.

"They gave the Oscars out Monday evenings in those days. I always played clarinet with my jazz band on Monday evenings. I don't like to fly. I don't like to get into a tuxedo. So I'm not going to suddenly cancel my band and fly to California. People made a big deal out of that, but I don't write movies to win awards."
—WOODY ALLEN, ON NOT ATTENDING THE ACADEMY AWARDS
THE NIGHT *ANNIE HALL* WON

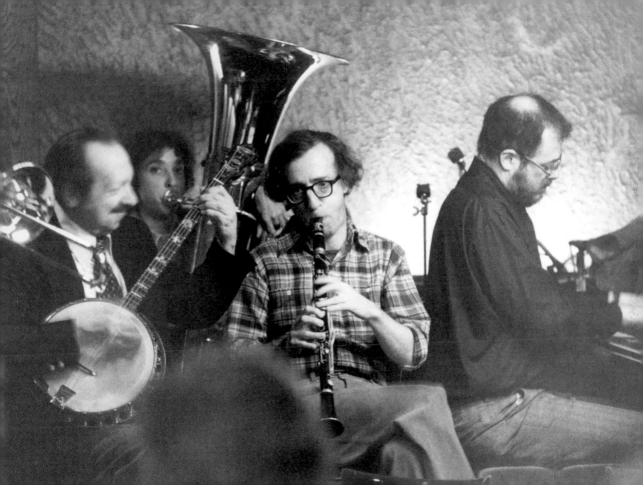

"On the one hand he'd be brilliant and his insights were amazing, but on the other hand, he'd be an idiot."
—DIANE KEATON

"He's definitely a little nutty."
—TONY ROBERTS

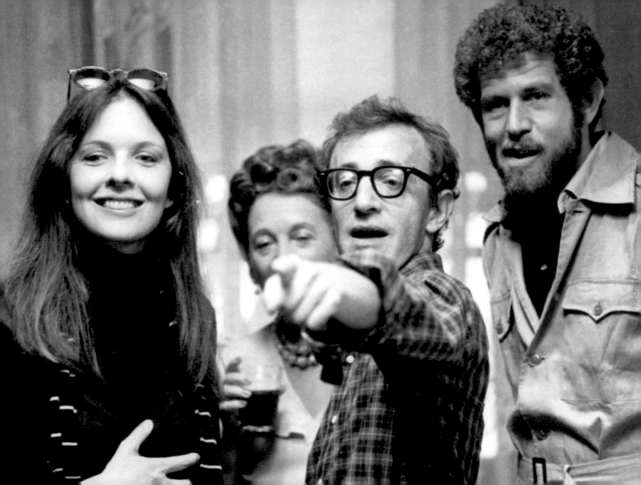

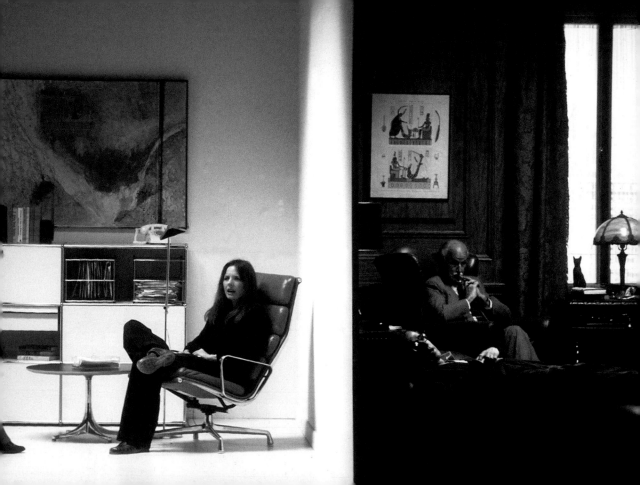

In making *Annie Hall*, Allen pulled out all the stops when it came to telling his story. Among the absurd techniques he employed were animation, subtitles, split screens, and breaking the fourth wall and addressing the camera directly.

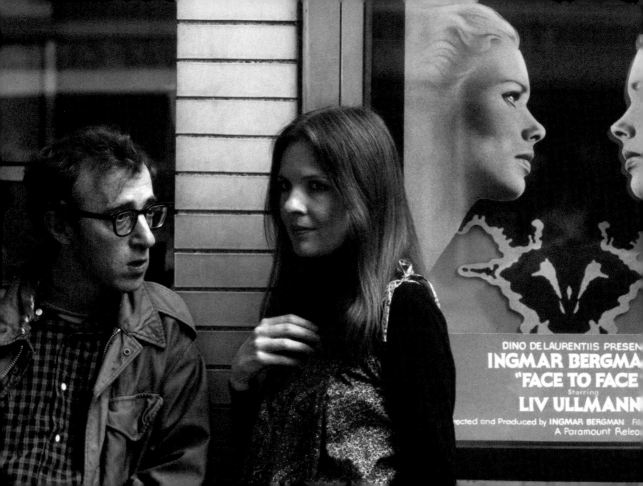

DINO DE LAURENTIIS PRESEN
INGMAR BERGMA
"FACE TO FACE
Starring
LIV ULLMANN
ected and Produced by INGMAR BERGMAN Fi
A Paramount Relea

"*Annie Hall* contains more intellectual wit and cultural references than any other movie ever to win the Oscar for best picture, and in winning the award in 1977 it edged out *Star Wars*, an outcome unthinkable today."

—ROGER EBERT

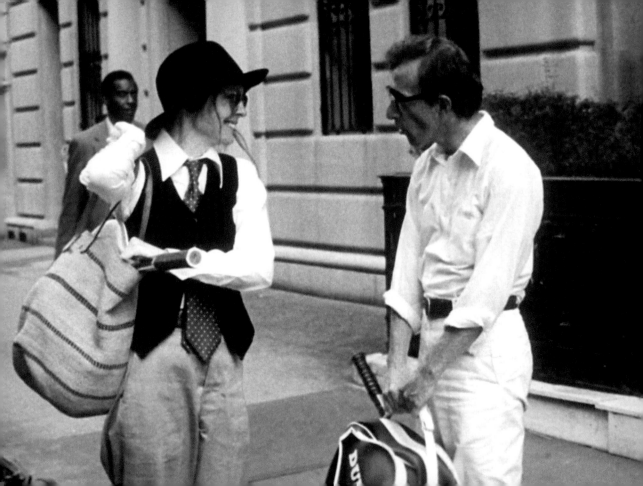

"The movie was originally supposed to be what my character was thinking, in a not really coherent fashion. But when Marshall Brickman saw the first cut, he said, 'I wrote it with you, and even I can't follow it.' So we restructured it and reshot the ending many times. I was able to find the love story, and audiences were charmed by it beyond my expectations."
—WOODY ALLEN, ON *ANNIE HALL*

"If my film makes one more person miserable,
I'll feel I've done my job."
—WOODY ALLEN

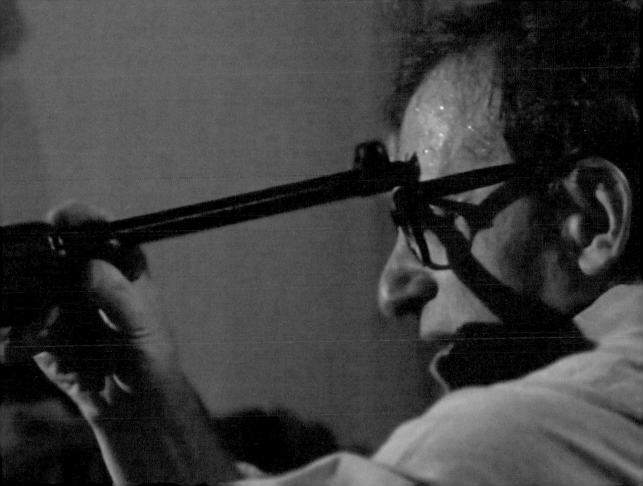

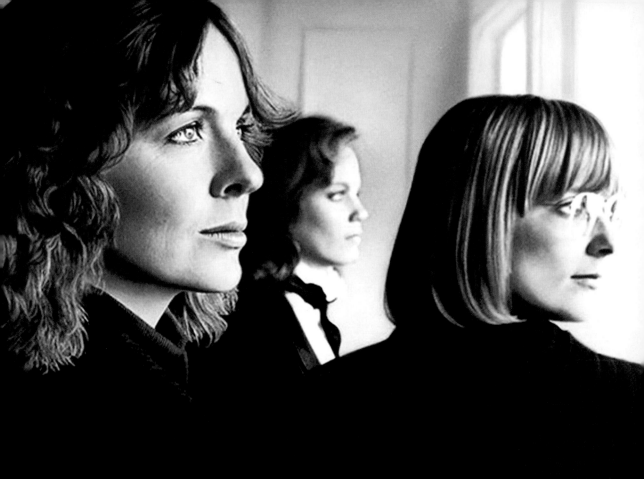

1978's *Interiors* was a real departure for Allen. Fans of his comedies were instead greeted with a stark family drama centering around three grown sisters coping with the breakup of their parents' marriage. Though many were highly critical of the film, it still managed to net five Oscar nominations.

"I didn't see it coming. There were people who loved it, and there were other people who thought I was committing a crime: I was in bad faith, I had violated my contract with the audience. I didn't feel it was fair. I thought I should be able to try something, even if I made the worst film in the world."
—WOODY ALLEN, ON THE REACTION TO INTERIORS

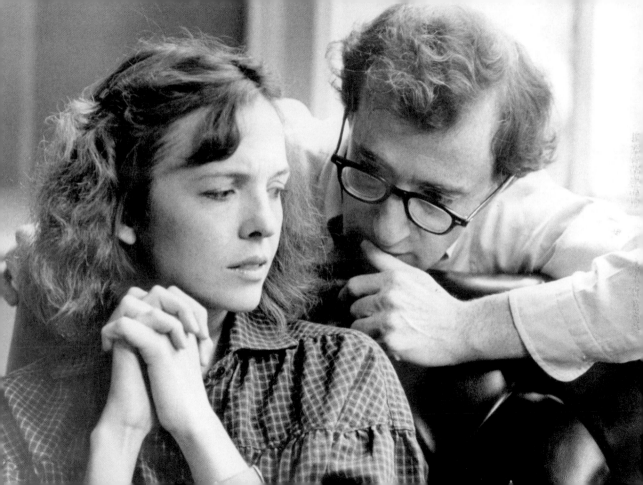

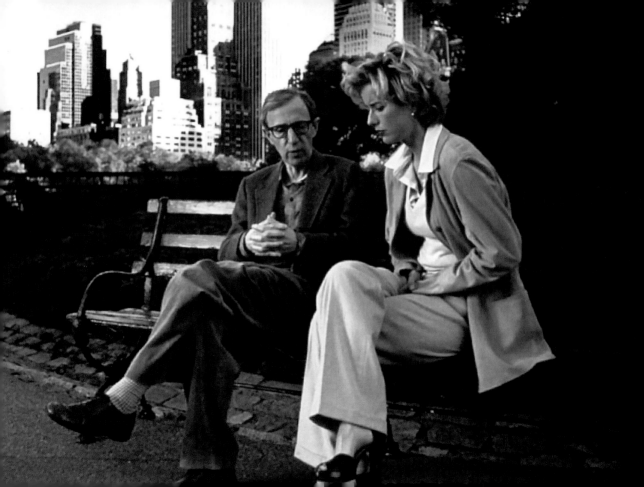

"I said, 'You know, you can do much better than me. You might want to get Martin Scorsese, or Mike Nichols, or Spike Lee, or Sidney Lumet . . .' I kept naming names, you know, and um, I said, 'Look, I've given you fifteen names of guys who are more talented than I am, and smarter and classier . . .' And they said, 'Yes, but they weren't available.'"
—WOODY ALLEN, AT THE 2002 ACADEMY AWARDS, EXPLAINING WHY HE WAS THE ONE INTRODUCING A MONTAGE OF NEW YORK MOVIES

Allen went back to comedy in 1979 with *Manhattan,* his beautiful black-and-white love letter to New York. Though he felt the film was seriously flawed, the moviegoing public thought otherwise and made it his biggest box-office success to that point. The film would also prove to be the final collaboration between Allen and Keaton for the next two decades.

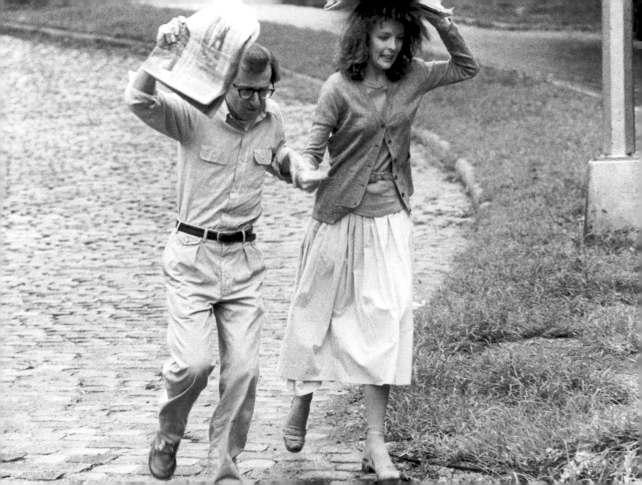

"I was so disappointed when I saw my final cut, I thought, if this is as good as I can do at this point, I shouldn't be making films. I went to United Artists and said, 'Look, don't put this out. I'll make another film, no charge.' They thought I was nuts. And it was a very, very big hit."
—WOODY ALLEN, ON *MANHATTAN*

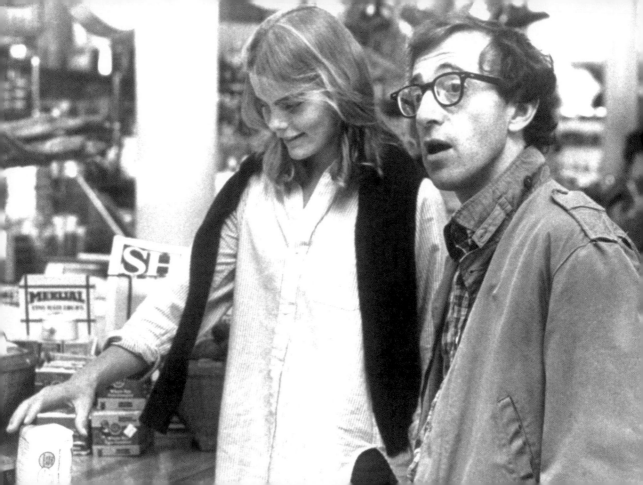

One element of *Manhattan* that raised some eyebrows was the fact that Allen's character, Isaac Davis, is romantically involved with a seventeen-year-old high school student, played by Mariel Hemingway. Years later Allen's personal life would somewhat imitate this particular piece of art.

"I don't think Woody Allen even remembers me. I went to see *Manhattan* and I felt like I wasn't even in it. I was pleased with the film because I looked pretty in it and I thought it was entertaining. But I only worked on the film for three days and I didn't get to know Woody. Who gets to know Woody?"
—MERYL STREEP

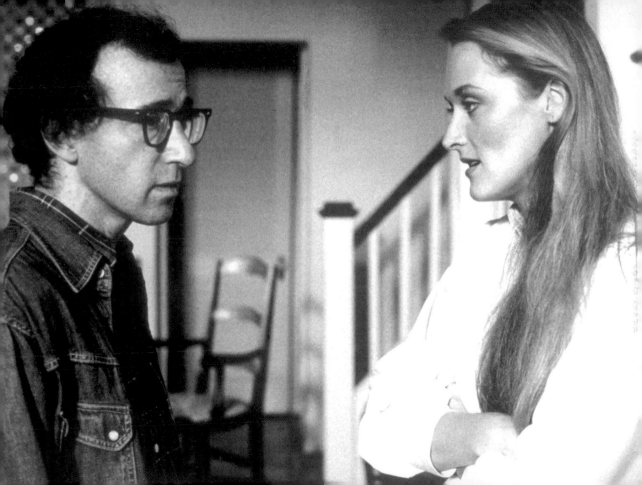

"Audiences don't have the same criteria I do. They say, 'Okay, you had some grandiose idea and maybe you failed, but we like this film.' So once again, I shut up and just felt I got away with it. I got off with my life."
—WOODY ALLEN, ON THE REACTION TO *MANHATTAN*

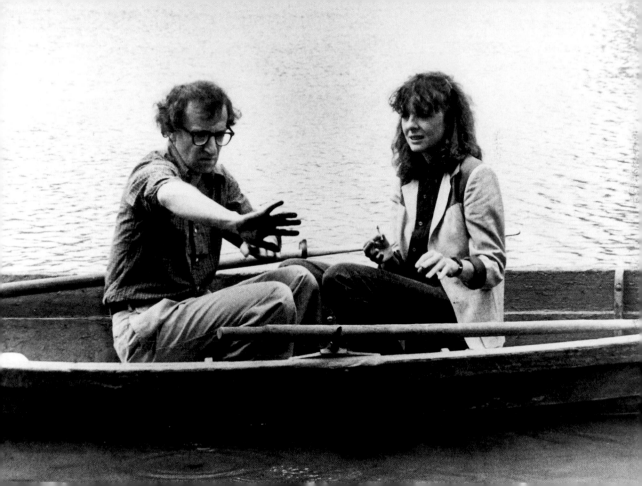

"Of course, I would love everybody to see my films. But I don't care enough ever to do anything about it. I would never change a word or make a movie that I thought they would like. I really don't care if they come or not. If they don't want to come, then they don't; if they do come, then great."
—Woody Allen

Many of Allen's fans took 1980's *Stardust Memories* as a personal affront. In the film Woody plays a director who's besieged by throngs of loyal followers begging him to return to the funny movies he used to make. As was the case in many of his films, he denied that the lead character was autobiographical.

"I certainly did not think my audience was stupid or grotesque, the way they seemed to be portrayed in the movie. I never had those thoughts—and if I did, I was much too smart to express them. I had an idea about an artist who had everything in the world and still couldn't beat his sense of mortality.
But it was taken as an act of hostility."
—WOODY ALLEN, ON *STARDUST MEMORIES*

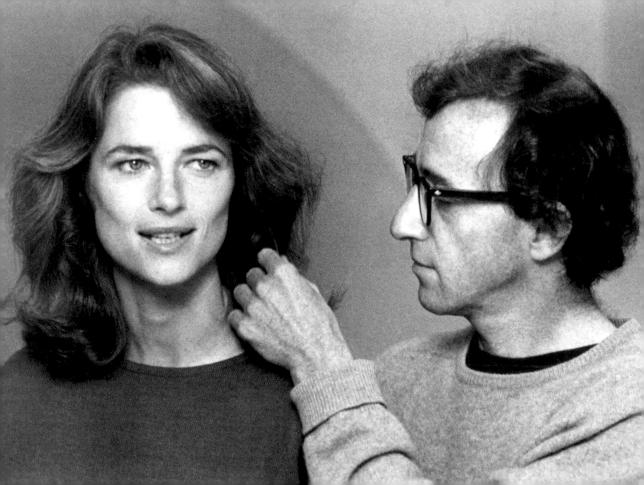

"The process of filmmaking is very musical, you get into
the rhythm and the rhythmics of how someone is, especially with
Woody Allen who is very much into body language
and body movement."
—CHARLOTTE RAMPLING

"A few months after the movie came out, John Lennon was murdered. In my movie, I show that exactly: The relationship between the audience and the entertainer is very often a kind of worship but also homicidal. I felt I had a good insight into that world."
—WOODY ALLEN, ON *STARDUST MEMORIES*

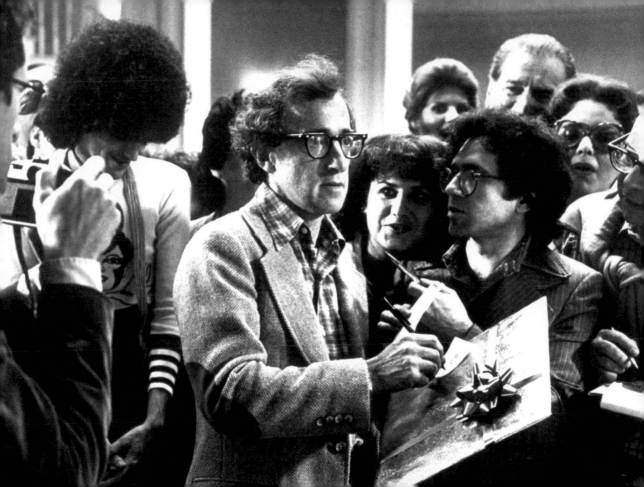

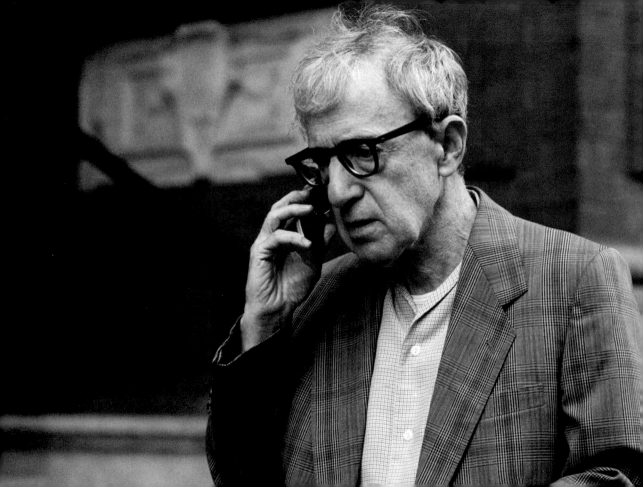

"If my films don't show a profit, I know
I'm doing something right."
—WOODY ALLEN

The lightly regarded *A Midsummer Night's Sex Comedy* (1982) was Allen's tribute, of sorts, to the Ingmar Bergman classic, *Smiles of a Summer Night*. Though largely forgotten, the film did signal the beginning of Woody's professional and personal relationship with actress Mia Farrow. The pair would go on to make thirteen films together.

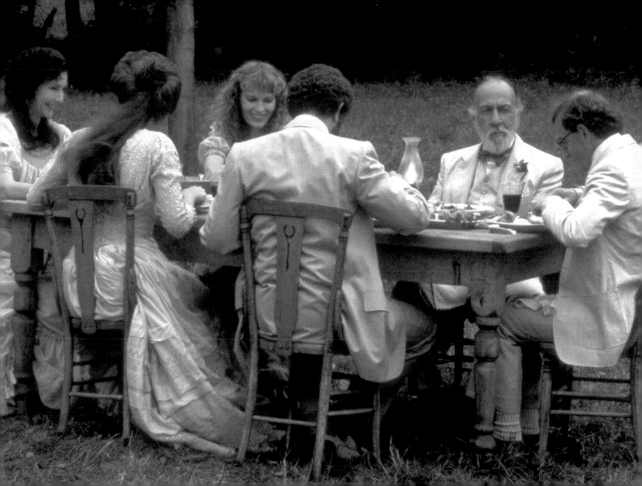

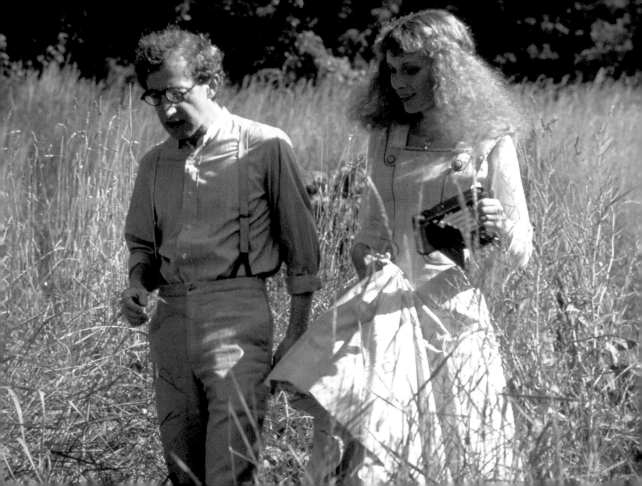

"Woody has no tolerance for the country. Within half an hour
after arriving he's walked around the lake and
is ready to go home. He gets very bored."
—MIA FARROW

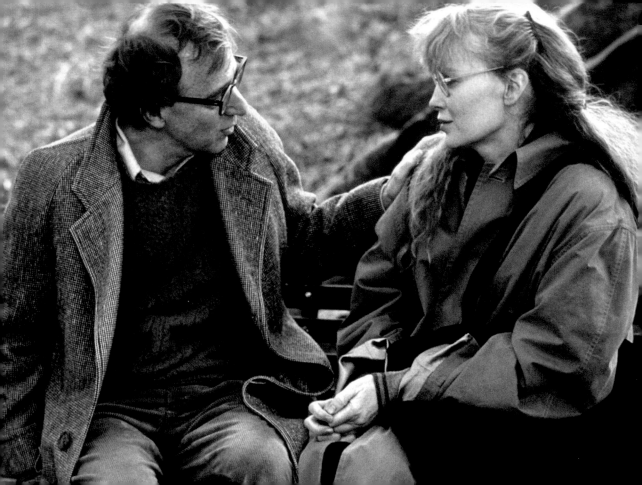

"I can only think that what made us throw in our lot together
is that the two of us met slightly later in life and that
we both have our own developed lives."
—WOODY ALLEN, ON MIA FARROW

"When I was a kid, movies from Hollywood seemed
very glamorous, but when you look back at them,
you can see out of the thousands of films that came out of
Hollywood there were really very few good ones statistically,
and those few that were good were made in spite of the studios.
I saw European films as a young man and they were
very much better. There's no comparison."
—WOODY ALLEN

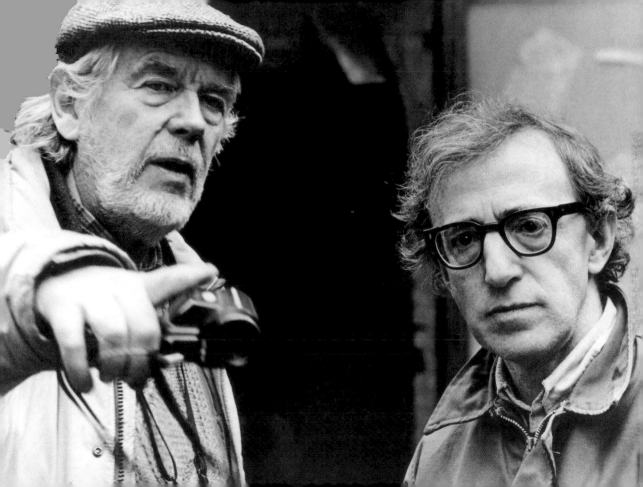

Allen went the "mockumentary" route with 1983's chameleon comedy *Zelig*. The movie cleverly used old black-and-white newsreel footage to place Woody's everyman protagonist Leonard Zelig in the company of famous people and moments of historical significance.

"It's true I had a lot of anxiety. I was afraid of the dark and suspicious of the light."
—WOODY ALLEN

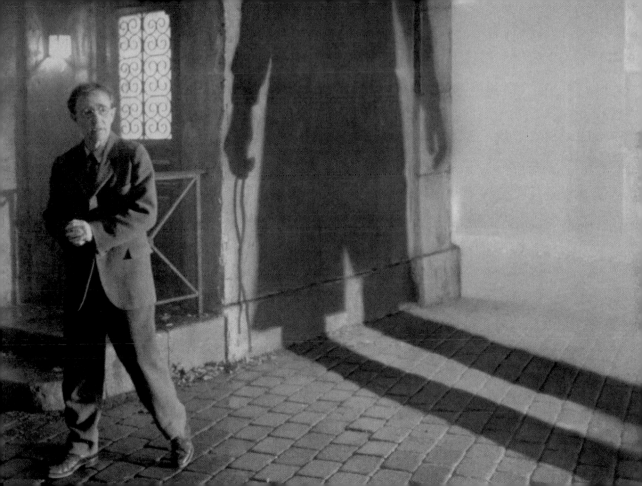

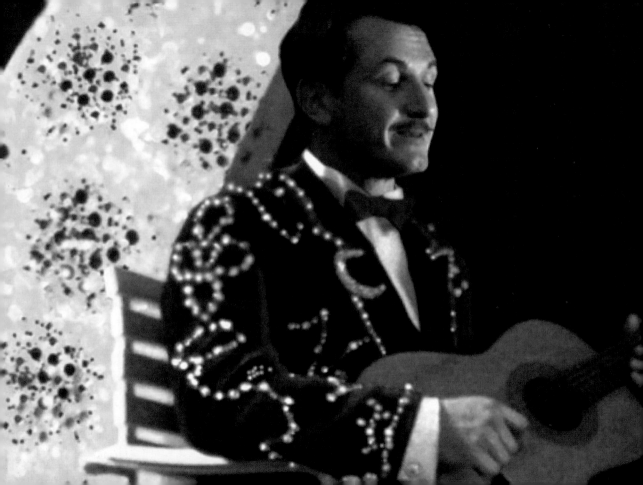

"It's not just that we're still interested in Woody Allen, he's still interested in telling stories."
—SEAN PENN

"I think there is too much wrong with the world to ever get too relaxed and happy. The more natural state, and the better one, I think, is one of some anxiety and tension over man's plight in this mysterious universe."

—Woody Allen

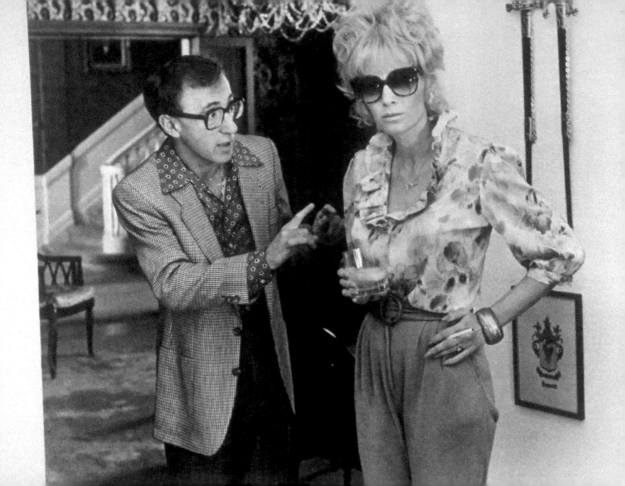

Woody was at his nebbishy best portraying the title character, a bottom-rung theatrical agent, in 1984's *Broadway Danny Rose*. But it was Mia Farrow who truly surprised audiences with her performance as a tough-talking lady with connections to the mob.

Farrow and Allen's personal relationship evolved slowly over several years. They had bumped into each other on occasion before they were formally introduced by actor Michael Caine at Elaine's restaurant in New York.

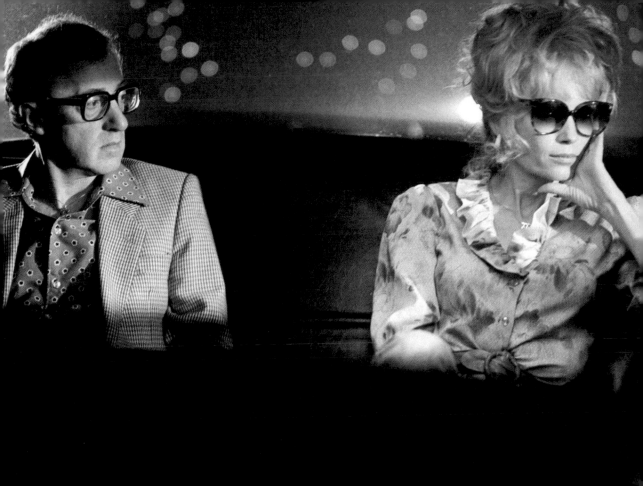

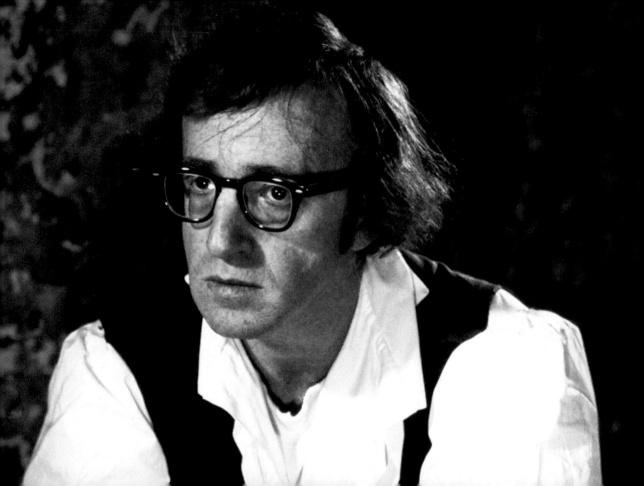

"Man was made in God's image. Do you really think God has red hair and glasses?"
—WOODY ALLEN

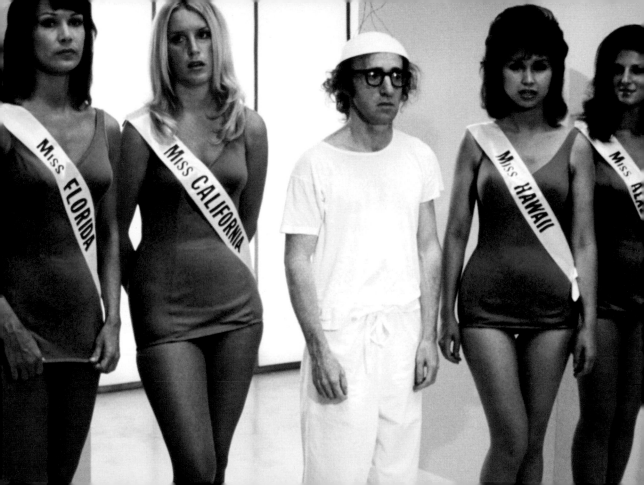

"He was even better-looking in real life. He had a great body, and he was physically very graceful."
—DIANE KEATON

"I never wanted movies to be an end. I wanted them to be a means so that I could have a decent life—meet attractive women, go out on dates, live decently. Not opulently, but with some security. I feel the same way now."
—Woody Allen

Allen took a break from acting with his 1985 Depression-era fantasy *The Purple Rose of Cairo*. Mia Farrow starred as a lonely housewife who ends up falling for a movie character, played by Jeff Daniels, who literally walks off the silver screen and into her life. Woody received a best original screenplay Oscar nomination for his efforts.

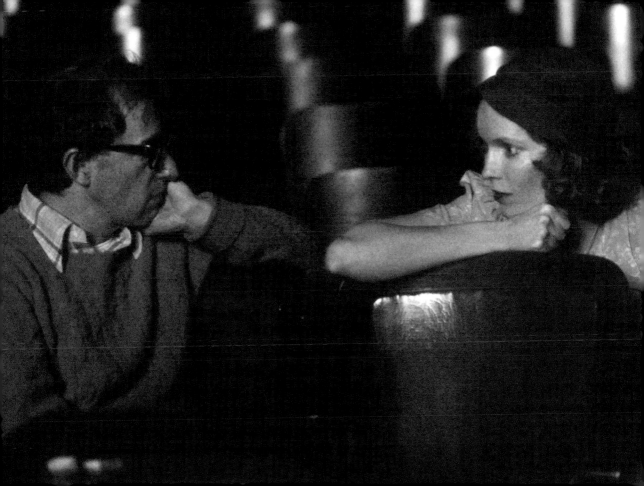

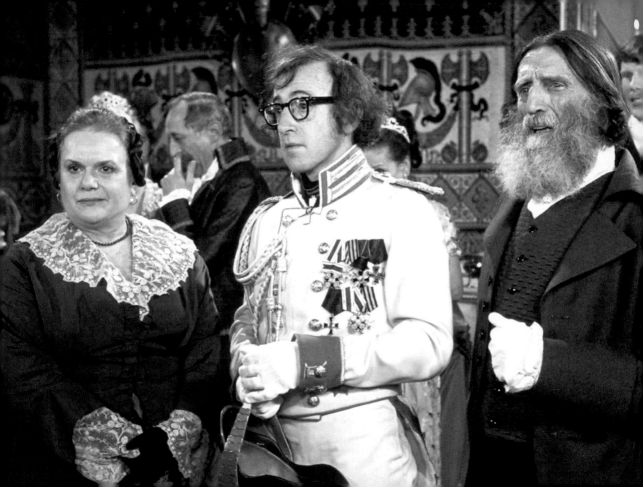

"I primarily feel I'm a writer who only directs so my stuff is not mangled on the screen. I'm a writer."
—Woody Allen

"Most of the time I don't have much fun.
The rest of the time
I don't have any fun at all."
—Woody Allen

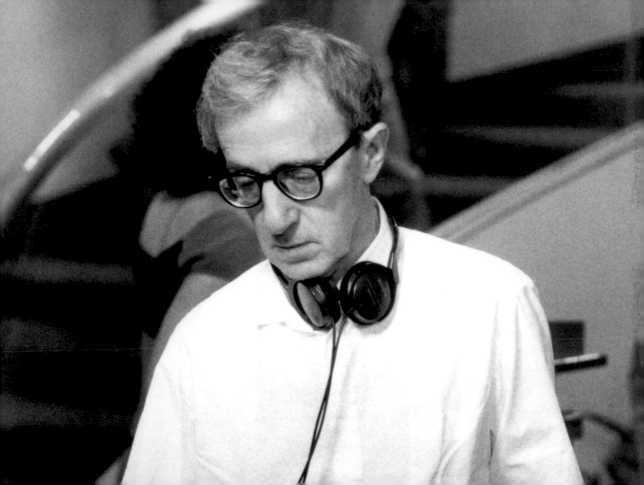

"If Woody Allen called me, I'd be there straight away. Who wouldn't? Truly."

—Julie Delpy

Hannah and Her Sisters (1986), a film about the relationship struggles of three sisters and their extended New York family, proved to be another Allen gem. Not only did the movie generate more box-office dollars than any of his previous pictures, but it also won three Academy Awards including Best Supporting Actor (Michael Caine), Best Supporting Actress (Dianne Wiest), and Best Original Screenplay.

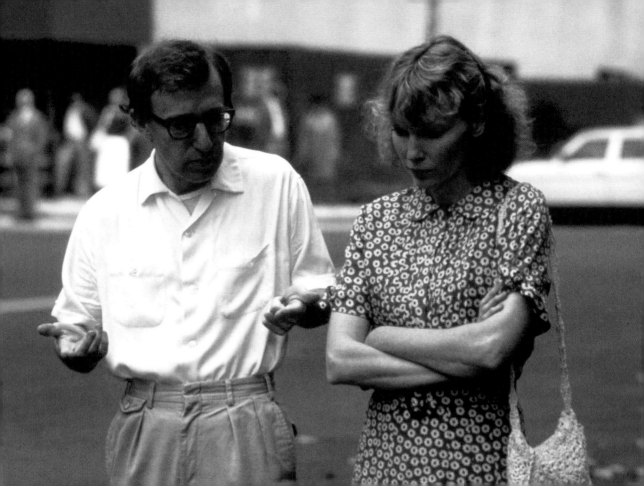

"I had written a different ending that was not as upbeat . . . But when I looked at it, it was like the picture dropped off the table. It was negative—and not like a good, Chekhovian negative, it was an inept negative, a downer. So I guided the thing instinctively to an ending where all the characters came out happy, and the picture was very successful. But I never felt positive about it. I felt I had a very poignant idea but finally couldn't bring it home."
—WOODY ALLEN, ON *HANNAH AND HER SISTERS*

"I could go on about our differences forever: She doesn't like the city and I adore it. She loves the country and I don't like it. She doesn't like sports at all and I love sports."
—WOODY ALLEN, ON MIA FARROW

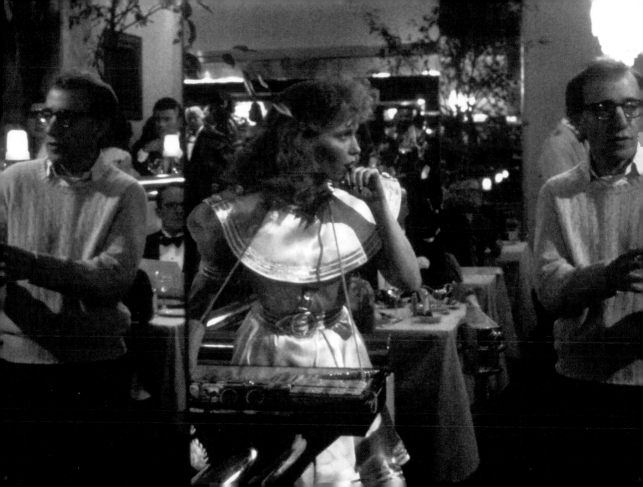

"Working with Woody Allen is like filming
Howard Hughes's will. It's a very mysterious and strange event.
You never get a peek at the whole will."
—MICHAEL O'DONOGHUE

"Woody feels it's more spontaneous if the actors don't know the entire story—it's a way of getting a more spontaneous reaction from them."
—Letty Aronson, film producer (and Woody Allen's sister)

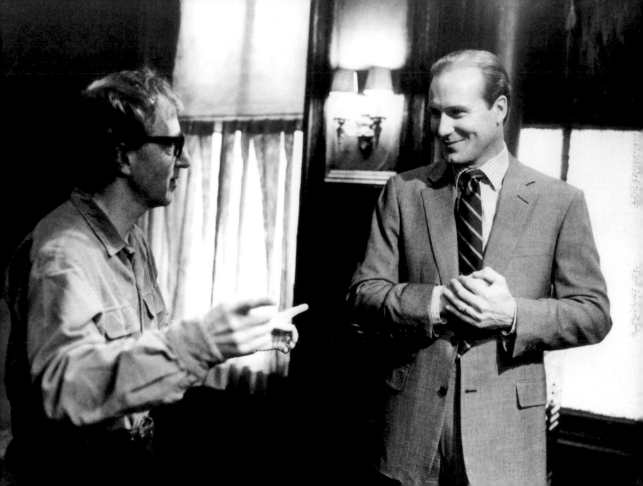

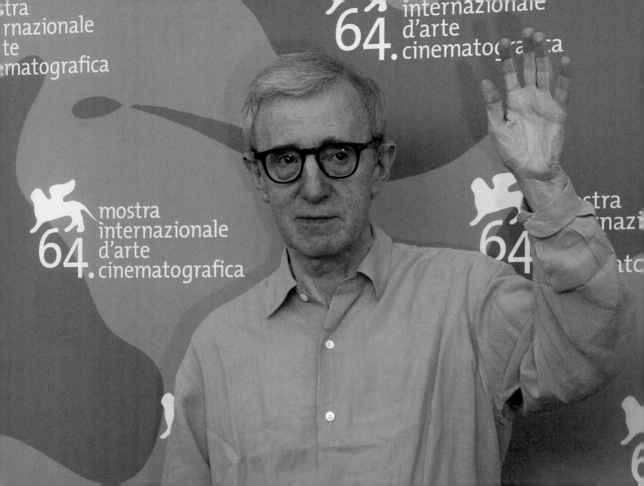

"I think what I'm saying is that I'm really impotent against the overwhelming bleakness of the universe and that the only thing I can do is my little gift and do it the best I can, and that is about the best I can do, which is cold comfort."
—Woody Allen

Allen's dark dramedy *Crimes and Misdemeanors* (1989) was a serious departure from the upbeat conclusion of *Hannah and Her Sisters*. The film featured two distinct stories, one concerning an ophthalmologist (Martin Landau) bent on eliminating his mistress, the other featuring Woody as a tough-luck documentary filmmaker. The movie garnered writing and directing Oscar nominations for Allen and a supporting acting nod for Landau.

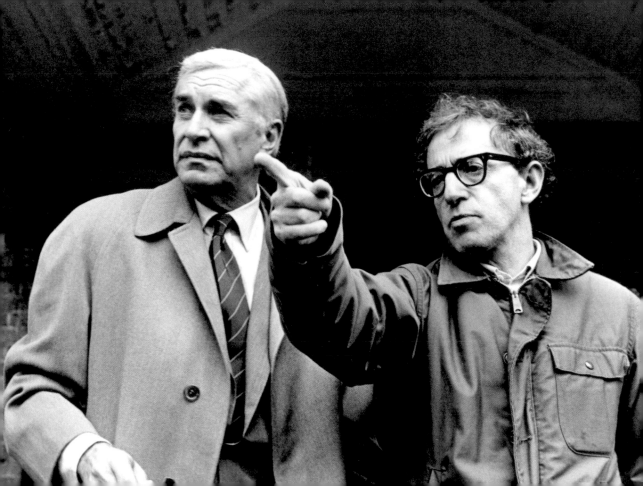

"For me, the interesting story was Marty Landau's story, and as I was putting that picture together, I so regretted that I had my story in there. As soon as I put myself in the picture, I felt that it ratcheted down in substance instantly, because I can only play a clown, a joker."
—WOODY ALLEN

"Woody Allen has done some excellent serious movies, too, like *Crimes and Misdemeanors*. Very overlooked movie, I think, and really his best."
—DAVID ZUCKER

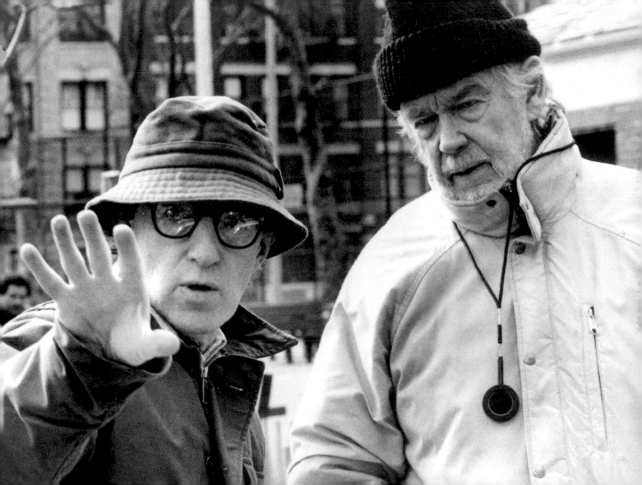

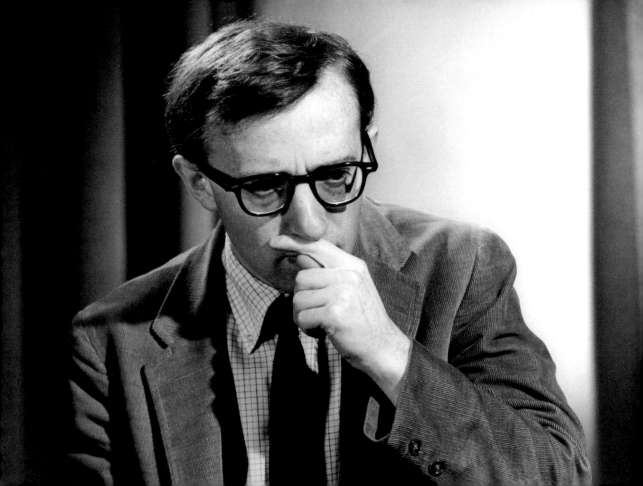

"The biggest flaw in being self-taught is there are gaps.
You self-teach yourself something and you think you know
something fairly well, but then there are gaps a university teacher
would have taught you as part of a mandatory program.
I would probably have been better off if I'd got a better
general education, but I was just so bored."
—WOODY ALLEN

"You can't compare anybody to Woody Allen."
—LARRY DAVID

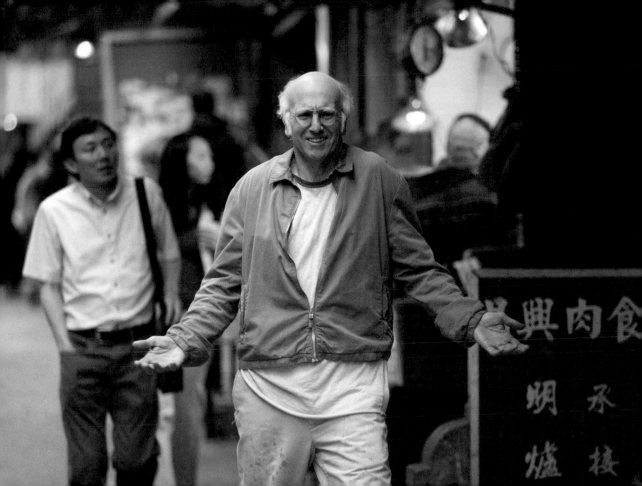

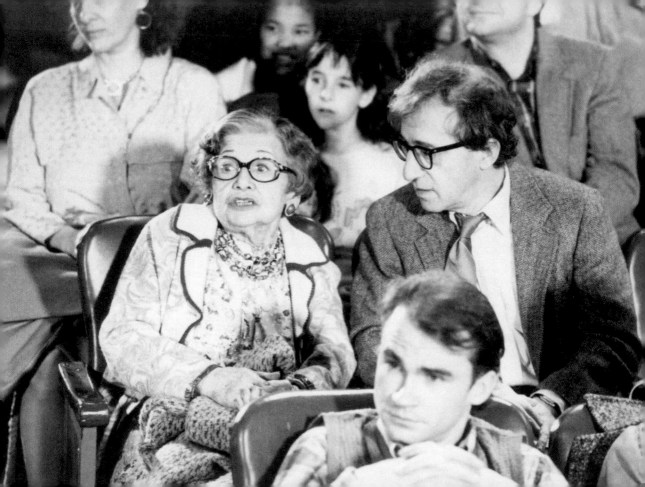

In 1989, Allen contributed a short film to the trilogy *New York Stories*. The other two directors involved in the project were Martin Scorsese and Francis Ford Coppola. Woody's story, a comedy, revolved around a lawyer, played by Allen, who can't seem to escape his overbearing mother.

"Not everybody has the staying power. Not everybody has the tenacity. And not everybody has so much to say."
—MARTIN SCORSESE

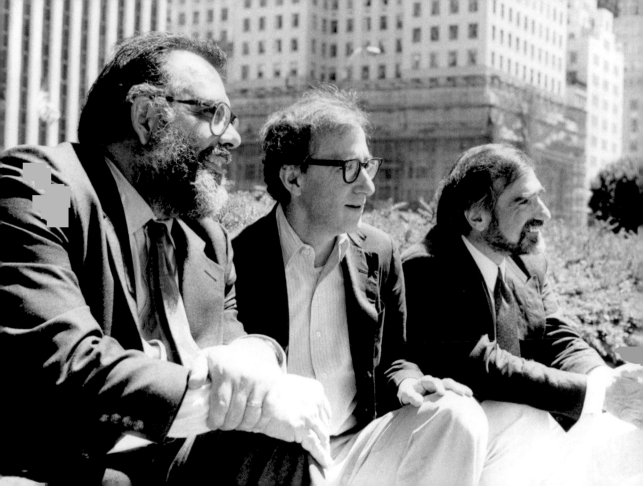

"I do the movies just for myself, like an institutionalized person
who basket-weaves. Busy fingers are happy fingers,
I don't care about the films. I don't care if they're
flushed down the toilet after I die."
—WOODY ALLEN

"Basically I am a low-culture person. I prefer watching baseball with a beer and some meatballs."
—WOODY ALLEN

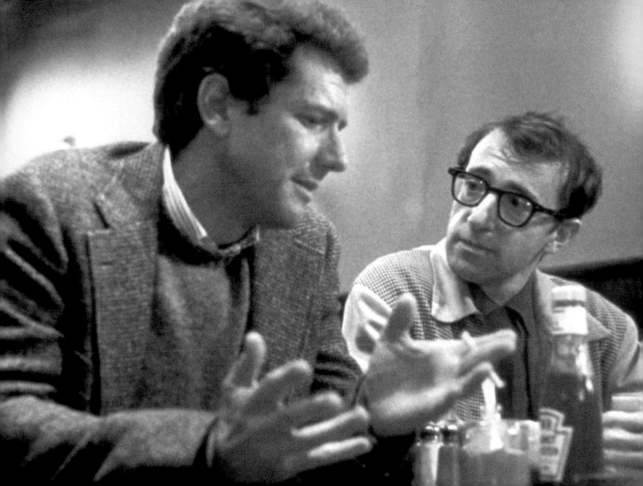

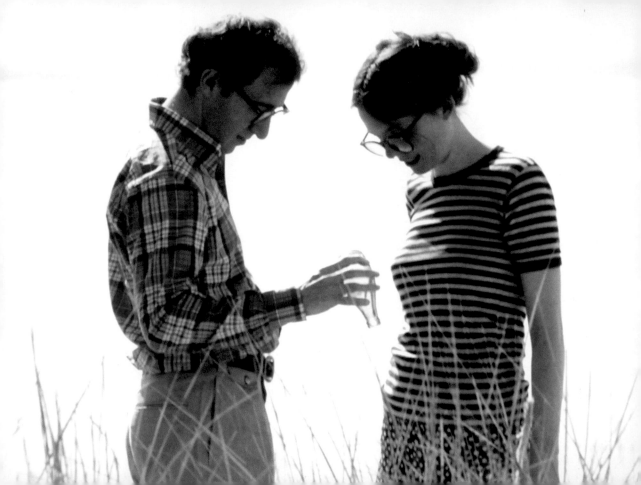

"How did I get to be his friend? I don't know how I got to be his friend. Because it's hard to become a friend of Woody's. He's a very, very private person and, yet, I'm his friend."
—DIANE KEATON

"He's also not normal. You know?
He's not of the normal stock."
—Mariel Hemingway

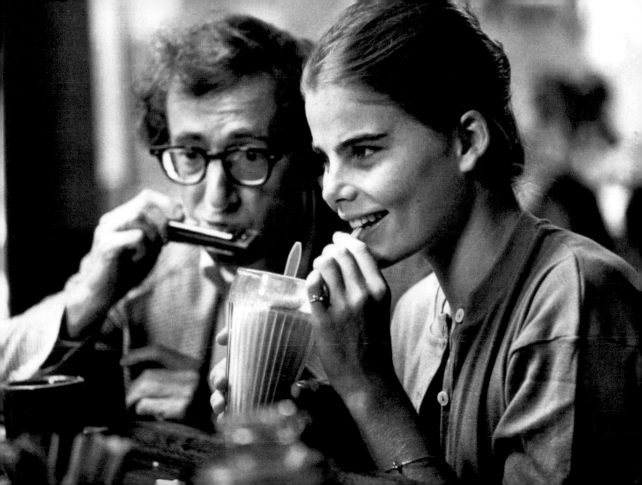

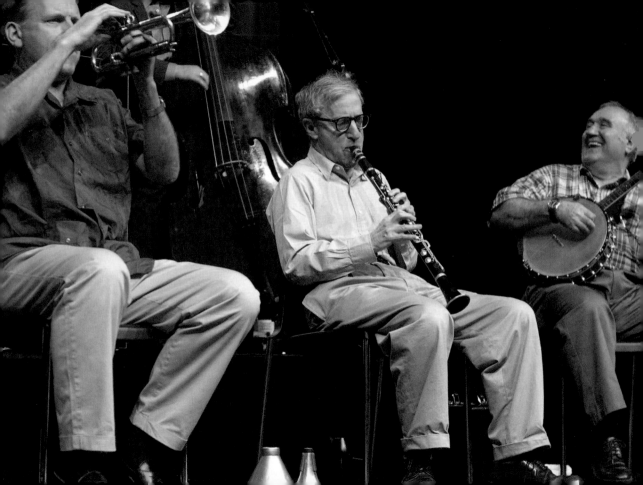

Woody Allen's love of jazz can be traced back to his youth. As a teenager he took up playing the clarinet, an instrument he still plays to this day. In fact, he still has a regular Monday night engagement playing with a New Orleans-style jazz band at New York's Carlyle Hotel.

"When I was growing up and I got up in the morning to go to school, I would turn on the radio and it would be Billie Holiday and Coleman Hawkins and Benny Goodman. This is what you heard in your house with popular music back then."
—WOODY ALLEN

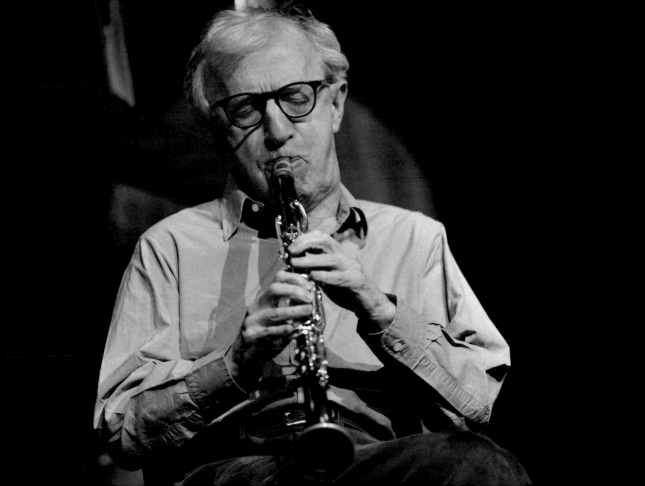

"Woody is a very musical fellow—really a very knowledgeable musician. He consciously, deliberately uses jazz, and understands how it works with the kinds of scenarios he writes."
—DICK HYMAN

"When we're on location doing a film there are times he brings his instrument with him and practices in the car on a break. But he practices all the time."

—LETTY ARONSON

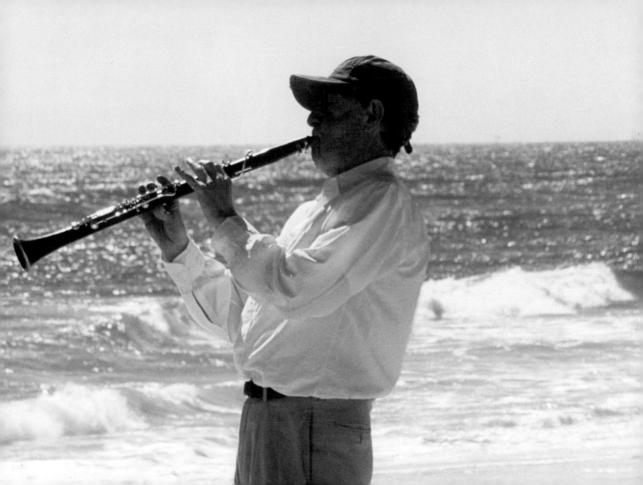

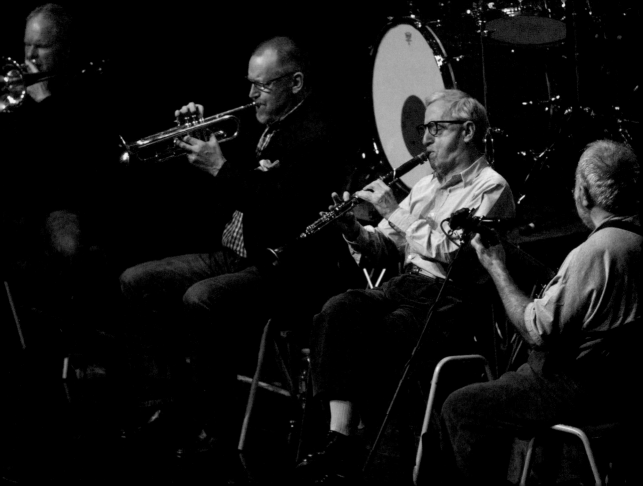

"I'm not saying this to be amusing: To be even as bad as I am, you do have to practice every day. I'm a strict hobby musician. I don't have a particularly good ear for music. I'm a very poor musician, like a Sunday tennis player."
—Woody Allen

Allen combined his comic and musical interests in 1990's *Alice*. The film starred Mia Farrow as a New York housewife who falls for a saxophone player (Joe Mantegna). Though the movie didn't make much noise at the box office, Woody received another Academy Award nomination, for Best Original Screenplay.

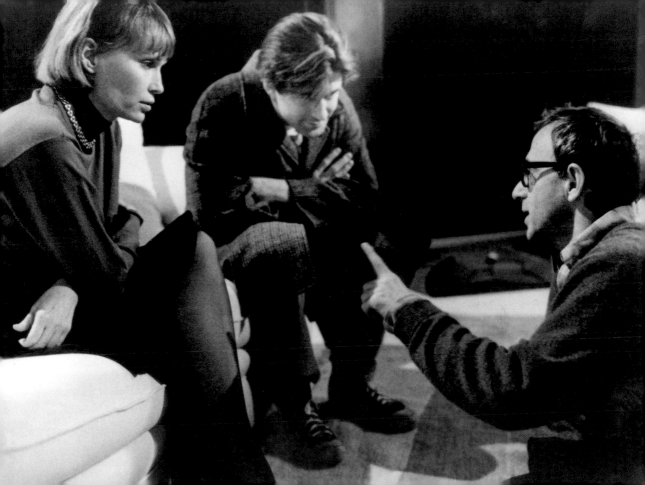

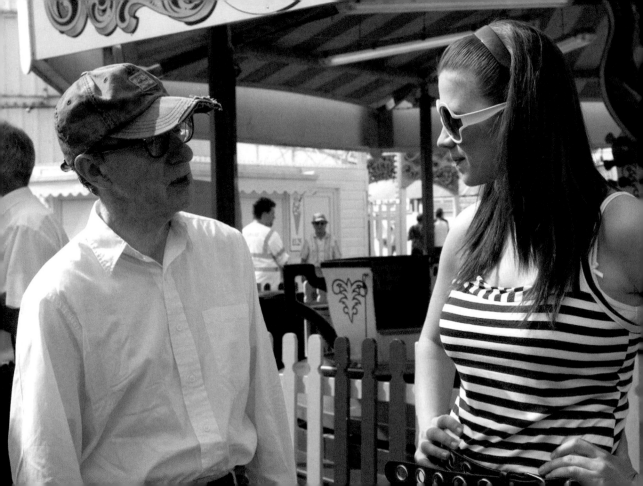

"With my complexion I don't tan, I stroke"
—WOODY ALLEN

"He is, without question, the best actor's director I've ever worked with."
—NAOMI WATTS

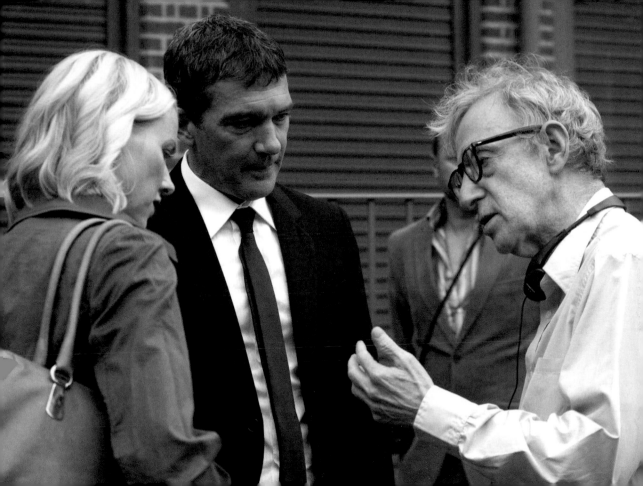

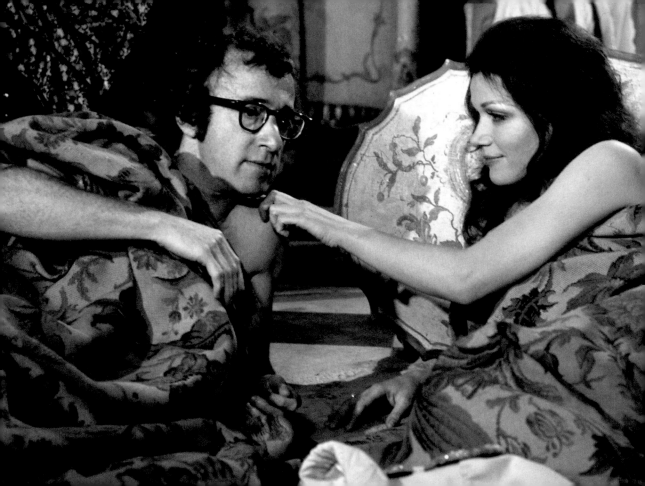

"For me, being famous didn't help me that much. It helped a little. Warren Beatty once said to me many years ago, being a star is like being in a whorehouse with a credit card, and I never found that. For me, it was like being in a whorehouse with a credit card that had expired."
—Woody Allen

"I was never bothered if a film was not well received. But the converse of that is that I never get a lot of pleasure out of it if it is. So it isn't like you can say, 'He's an uncompromising artist.' That's not true. I'm a compromising person, definitely. It's that I don't get much from either side."
—WOODY ALLEN

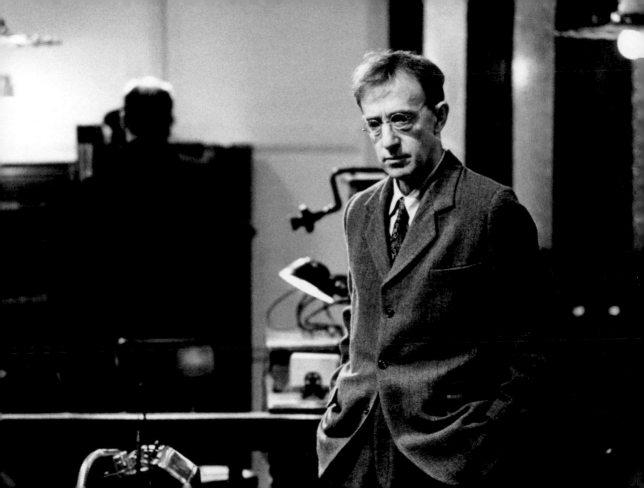

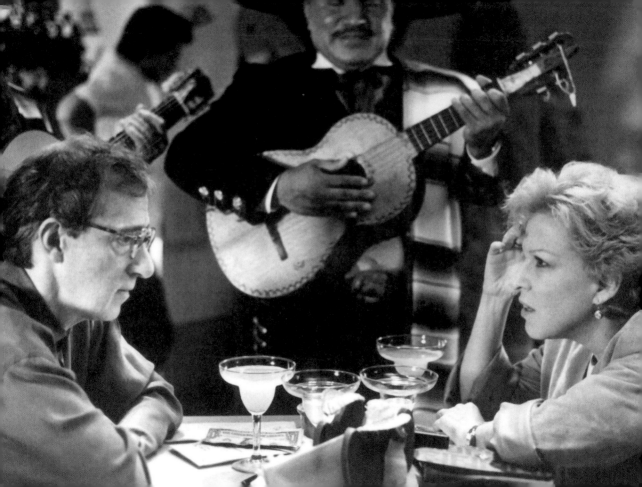

In 1991 Woody stepped out from behind the camera to star opposite Bette Midler in Paul Mazursky's "marriage-on-the-rocks" comedy, *Scenes from a Mall*. The film did not do well and is largely forgotten when discussing Allen's considerable list of credits.

"If it turns out that there is a God, I don't think that he's evil.
But the worst that you can say about him
is that basically he's an underachiever."
—WOODY ALLEN

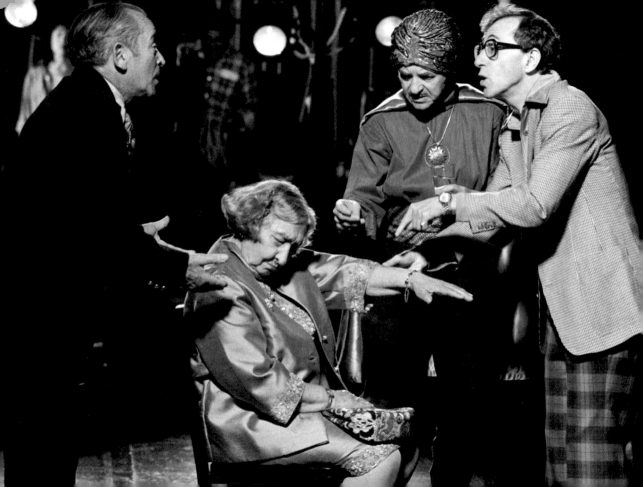

"I never write down to them. I always assume that they're all as smart as I am . . . if not smarter."
—WOODY ALLEN, ON HIS AUDIENCE

"What if Woody Allen called me and said, 'I'm working on this movie and there's a really divine role for you. We want exactly you!' It would be such a fantasy. Forget it! My idol, Woody Allen!"
—Isaac Mizrahi

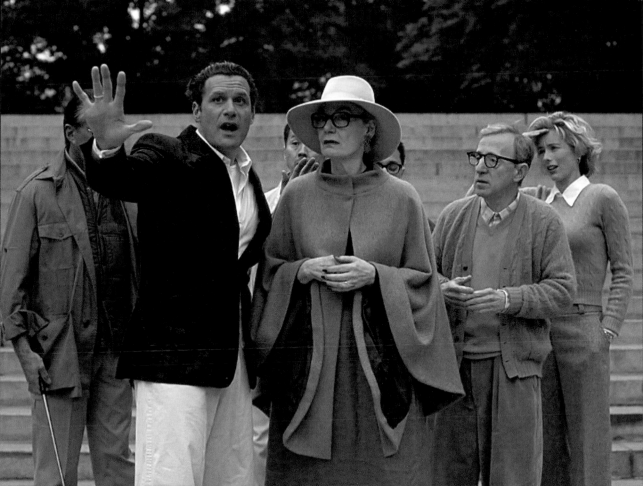

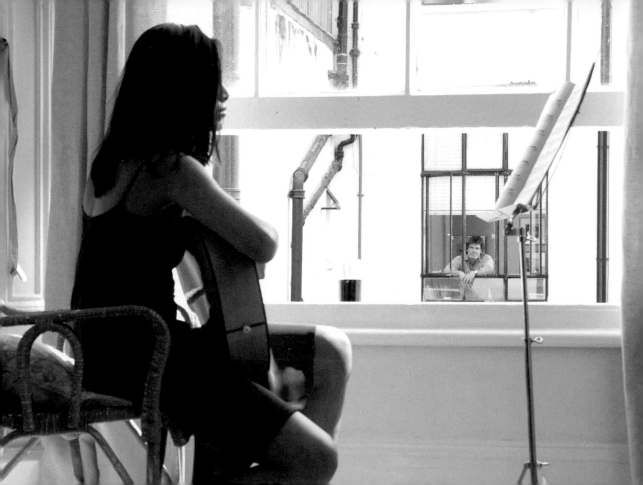

"Everyone told me that he was going to be very quiet and very elusive and that he was probably not going to talk to me. But that wasn't the case at all."
—FREIDA PINTO

"I've never felt that if I waited five years between films, I'd make better ones. I just make one when I feel like making it. And it comes out to be about one a year. Some of them come out good, and some of them come out less than good. Some of them may be very good and some may be very bad. But I have no interest in an overall plan for them or anything."
—Woody Allen

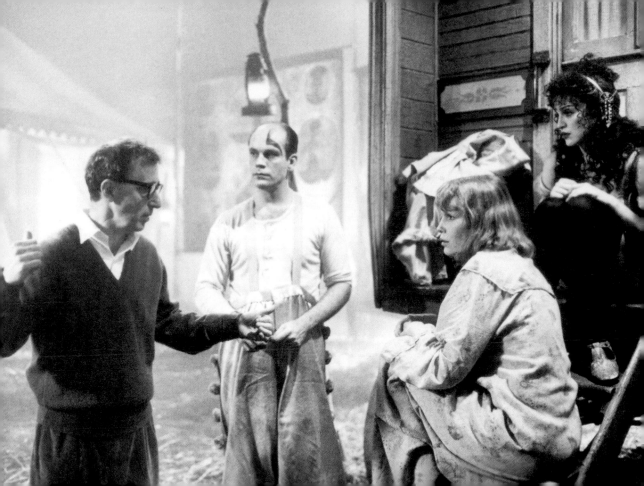

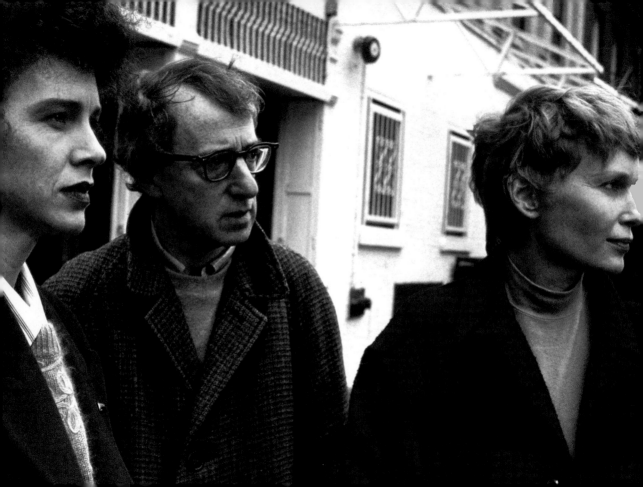

Allen followed 1991's *Shadows and Fog*, based on one of his one-act plays, with the caustic couples drama *Husbands and Wives* (1992). The movie, about faltering marriages, seemed to coincide with Allen's own very public breakup with the film's star, Mia Farrow. Tabloids had a field day as it was revealed that Woody was involved in a relationship with Farrow's adopted daughter, Soon-Yi Previn.

"The movie had no relation to my life in any way. But when it came out, my private life was all over the headlines. I could always work under stress, though. Whenever things go bad, the two things I've always been able to do are lose myself in work and lose myself in sleep."
—WOODY ALLEN, ON *HUSBANDS AND WIVES*

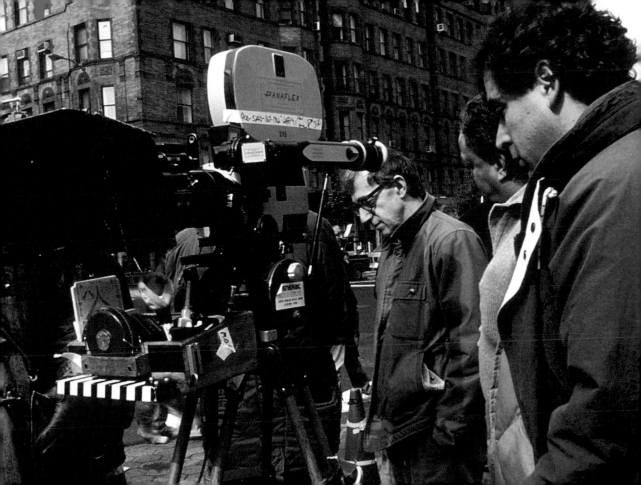

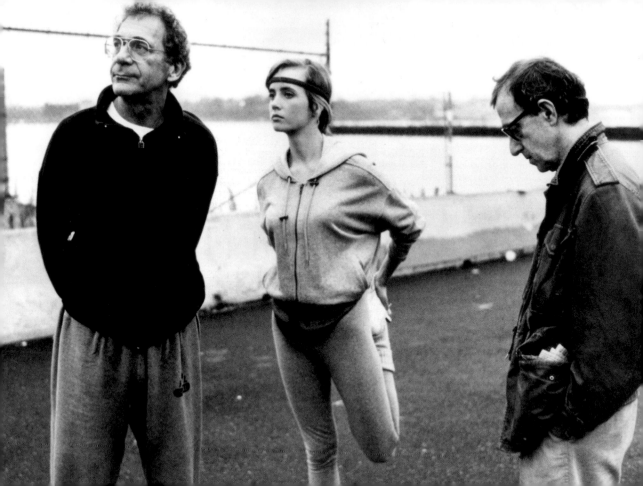

"Certain things are autobiographical, certain feelings, even occasionally an incident, but overwhelmingly they're totally made up, completely fabricated."
—WOODY ALLEN, ON HIS FILMS BEING AUTOBIOGRAPHICAL

"What was the scandal? I fell in love with this girl, married her. We have been married for almost fifteen years now. There was no scandal, but people refer to it all the time as a scandal. I kind of like that in a way because when I go I would like to say I had one juicy scandal in my life."
—WOODY ALLEN

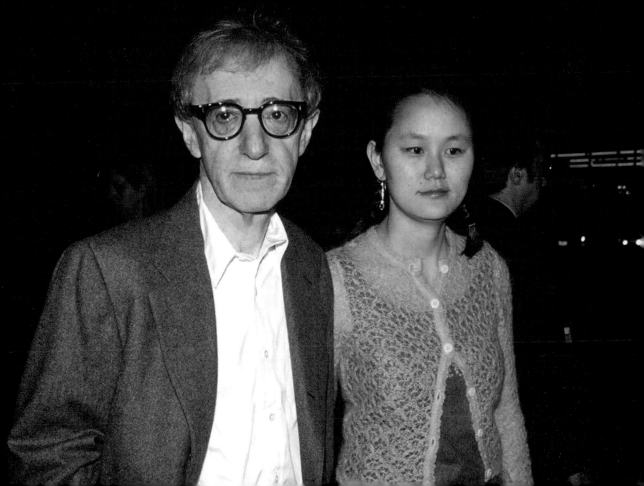

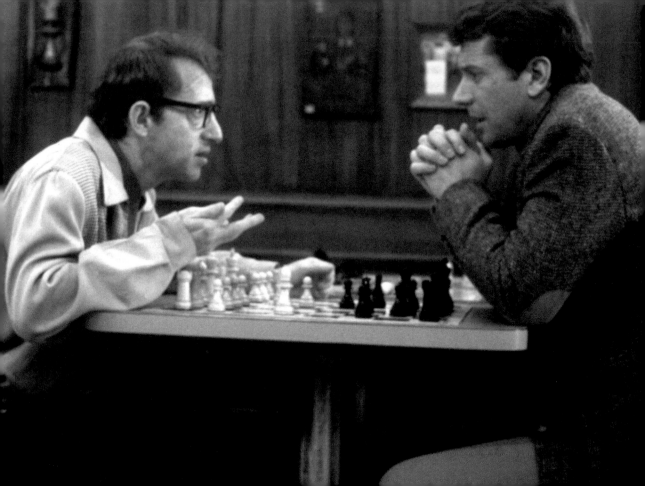

"They're not always him. When he writes, he writes the way he speaks so everyone just thinks it's him."
—LETTY ARONSON, ON ALLEN'S CHARACTERS BEING BASED ON HIMSELF

"I think universal harmony is a pipedream and it may be more productive to focus on more modest goals, like a ban on yodeling."
—WOODY ALLEN

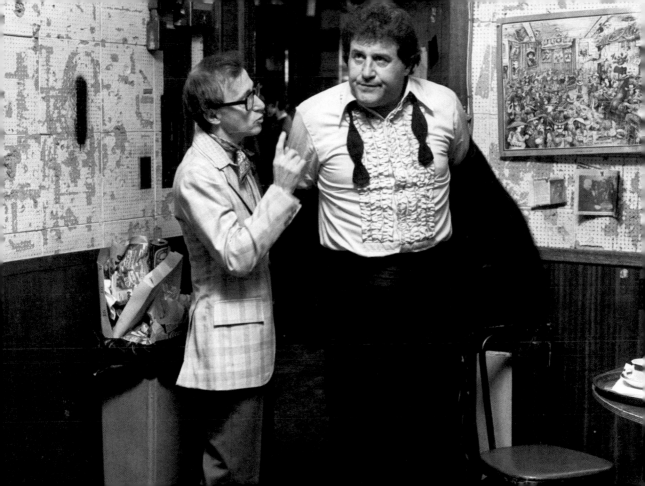

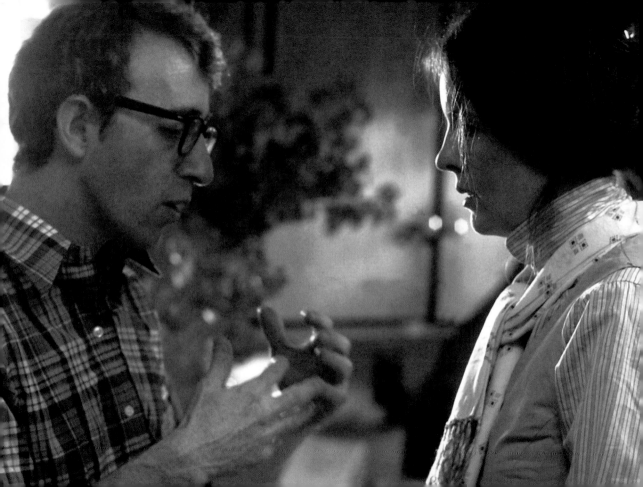

Amidst all the turmoil surrounding his personal life, Allen went to work with a pair of trusted friends on the 1993 comedy *Manhattan Murder Mystery*. Marshall Brickman, who cowrote *Sleeper*, *Annie Hall*, and *Manhattan* with Allen was back in the fold, as was former flame and leading lady Diane Keaton.

"I've always felt that the two great movie comediennes of all time were Judy Holliday and Diane Keaton."
—WOODY ALLEN

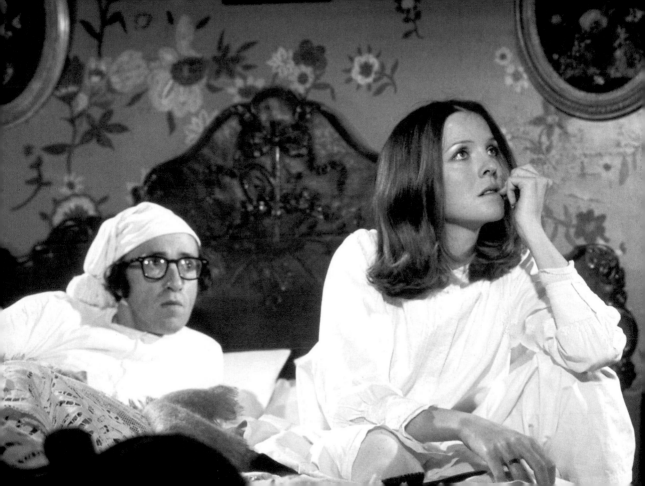

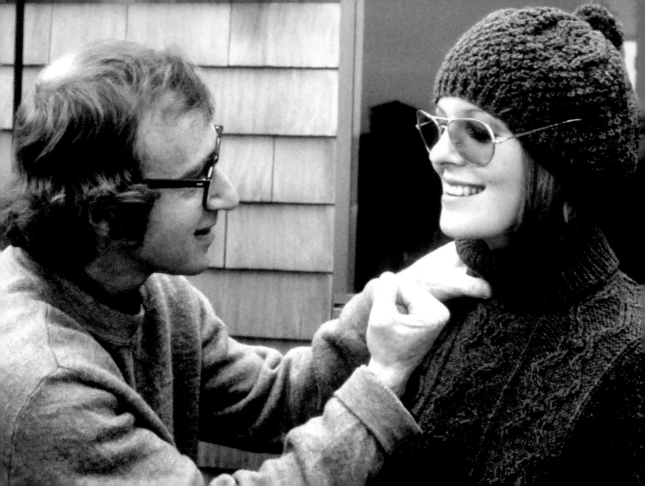

"Woody got used to me. He couldn't help himself; he loved neurotic girls."
—Diane Keaton

"If they said to me tomorrow, 'We're pulling the plug and we're not giving you any more money to make films,' that would not bother me in the slightest. I mean, I'm happy to write for the theatre. And if they wouldn't back any of my plays, I'm happy to sit home and write prose. But as long as there are people willing to put up the vast sums of money needed to make films, I should take advantage of it. Because there will come a time when they won't."

—WOODY ALLEN

Allen scored another critical hit with the 1994 theater-based comedy *Bullets Over Broadway*. Featuring an ensemble cast including John Cusack, Dianne Wiest, and Chazz Palminteri, the film received seven Academy Award nominations, including writing and directing nods for Allen. It was Wiest, however, who took home her second gold statue, both coming from her work with Woody.

"They're political and bought and negotiated for—although many worthy people have deservedly won—and the whole concept of awards is silly. I cannot abide by the judgment of other people, because if you accept it when they say you deserve an award, then you have to accept it when they say you don't."
—WOODY ALLEN, ON THE ACADEMY AWARDS

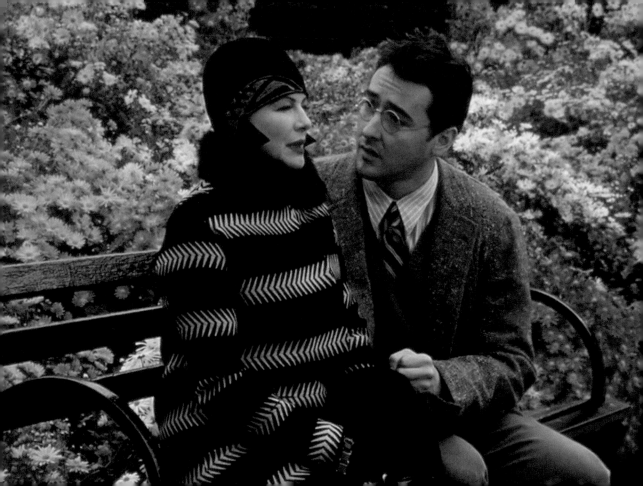

"Woody is so musical in his filmmaking. I've never worked with anyone I've trusted so completely. He won't let you hit a false note."
—DIANNE WIEST

"My relationship with Hollywood isn't love-hate, it's love-contempt. I've never had to suffer any of the indignities that one associates with the studio system. I've always been independent in New York by sheer good luck. But I have an affection for Hollywood because I've had so much pleasure from films that have come out of there. Not a whole lot of them, but a certain amount of them have been very meaningful to me."
—WOODY ALLEN

"A lot of actors that I was working with would say, 'Am I okay? He doesn't talk to me. He hates me.' I said, 'No, he loves you. If he starts talking to you that means you're gonna get fired. You don't want him talking to you.'"
—Chazz Palminteri

Despite his cantankerous and very public split with Mia Farrow, Allen reportedly considered casting her as his wife in 1995's *Mighty Aphrodite*. Though he later thought better of it, working with his exes was a formula that had served him well in past films with Louise Lasser and Diane Keaton. In this case, the role eventually went to Helena Bonham Carter.

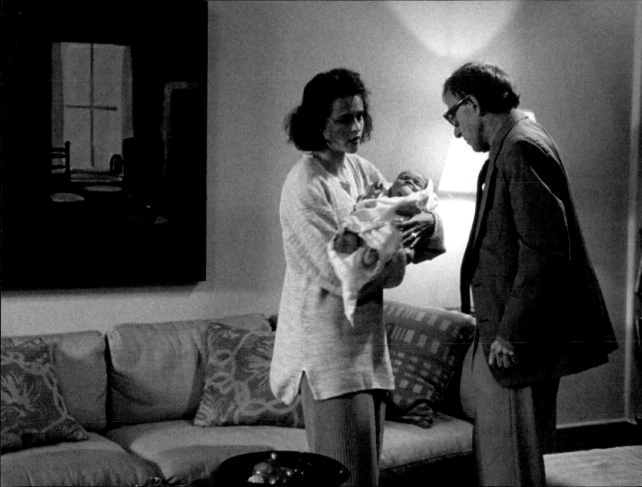

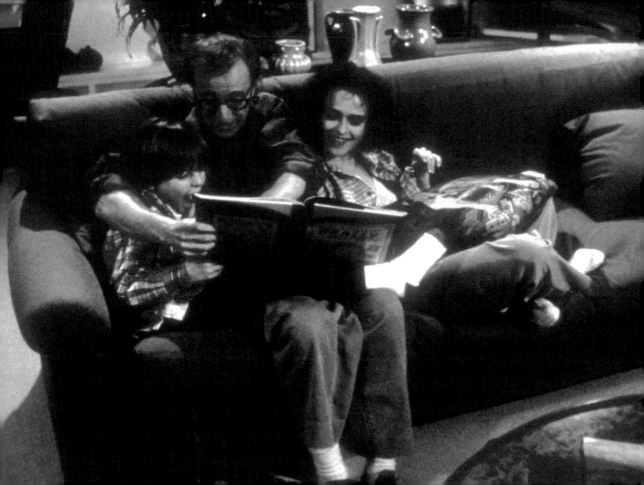

"There was no ripple professionally for me at all when I was in the papers with my custody stuff. I made my films, I worked in the streets of New York, I played jazz every Monday night, I put a play on. Everything professionally went just the same. There were no repercussions. There was white-hot interest for a while, like with all things like that, and then it became uninteresting to people."

—Woody Allen, on the issues surrounding his breakup with Mia Farrow

"My one regret in life is that I am not someone else."
—WOODY ALLEN

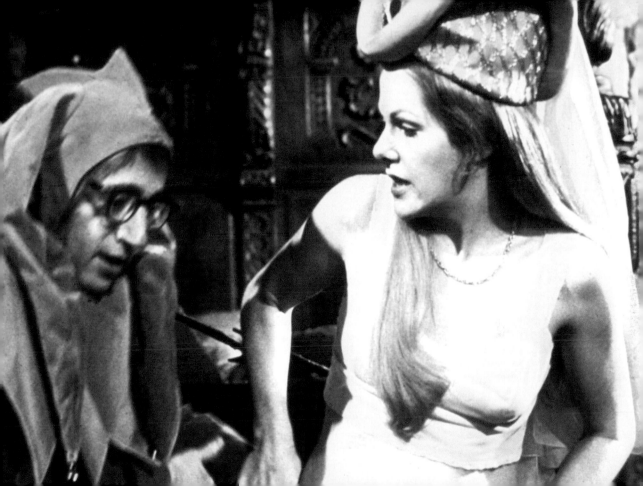

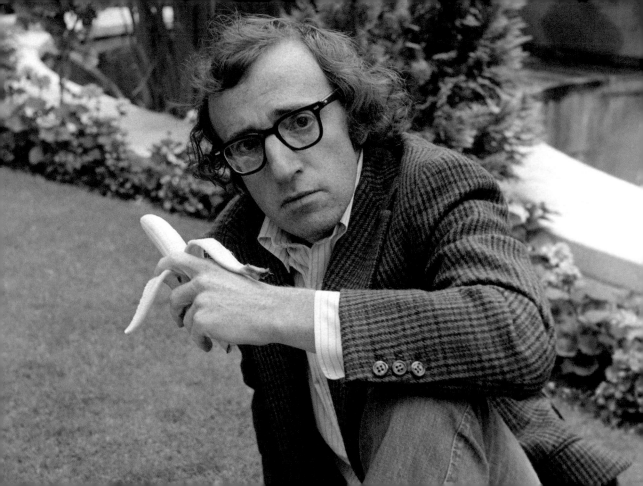

"He's kinda peerless."
—CHRIS ROCK

As with so many of his previous films, Woody received a
Best Original Screenplay nomination for *Mighty Aphrodite*.
But once again it was one of his actors, this time Mira Sorvino,
who took home an Oscar for Best Supporting Actress.

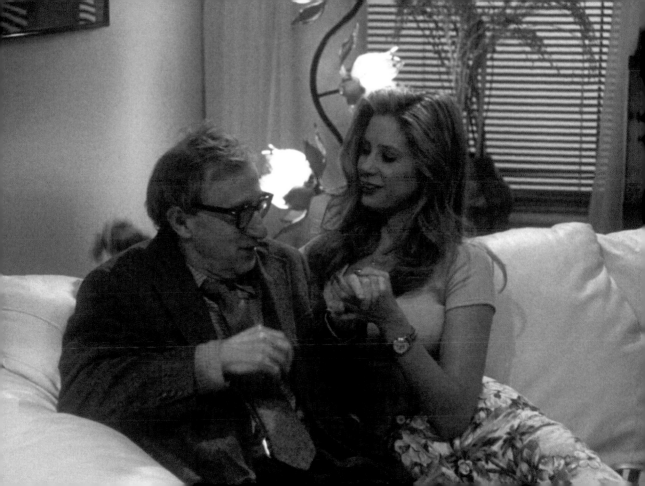

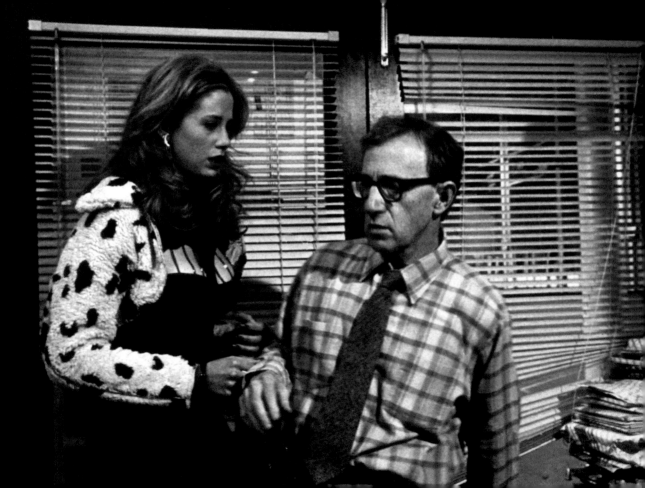

"Working with Woody Allen had been a dream of mine since I was twelve, when I was reading *Getting Even* and *Without Feathers*. I was in a high school production of *Play It Again, Sam*. I played the Diane Keaton role in that. So getting to work for him was such a dream come true, and I never thought it could happen that early in my career. That was just an amazing role and a great experience."

—Mira Sorvino

"I can bring stars, I've worked with terrific cameramen, but people still have a better chance of making their $150[million] films because they're not interested in the types of profits I can bring if I'm profitable."
—WOODY ALLEN

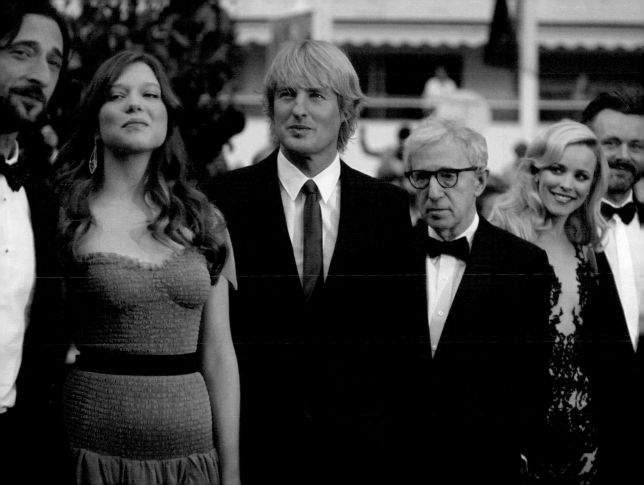

"I also feel that humor, just like Fred Astaire dance numbers or these lightweight musicals, gives you a little oasis. You are in this horrible world and for an hour and a half you duck into a dark room and it's air-conditioned and the sun is not blinding you and you leave the terror of the universe behind and you are completely transported into an escapist situation."
—WOODY ALLEN

Though music had always played a big part in his movies, it wasn't until 1996's *Everyone Says I Love You* that Allen made an honest-to-goodness musical. Featuring a star-studded ensemble cast, including Julia Roberts and Goldie Hawn, the film signaled a glimpse of things to come, as Woody left his New York comfort zone to shoot scenes abroad in Paris and Venice.

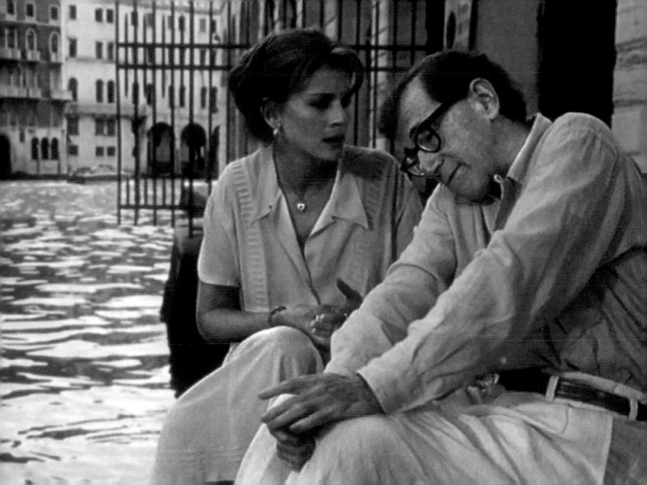

The story goes that Allen did not tell any of the actors that *Everyone Says I Love You* was going to be a musical until they had already signed on to do the film. He purposely wanted to go for less-than-professional sounding singing voices. Drew Barrymore ended up being the only cast member who did not do her own singing.

"Whenever they ask women what they find appealing in men, a sense of humor is always one of the things they mention. Some women feel power is important, some women feel that looks are important, tenderness, intelligence . . . but sense of humor seems to permeate all of them."
—WOODY ALLEN

The dark 1997 comedy *Deconstructing Harry* revolved around the clever conceit of an author facing the relationship demons of his past in both their real and fictional forms. Allen initially offered the title role to other actors but eventually ended up playing the part, for which he seemed particularly well-suited, himself.

"If I write a film and there is a part in it for me—great. But if I sit down in advance and think, 'I'd like to be in this film,' or 'It's been a long time since I've been in a film so it would be fun to do one,' then all of a sudden there's an enormous amount of limits and compromise. I can only play a few things so that compromises the idea instantly. I think *Deconstructing Harry* would have been better with Dustin Hoffman or Robert De Niro, for sure."
—WOODY ALLEN

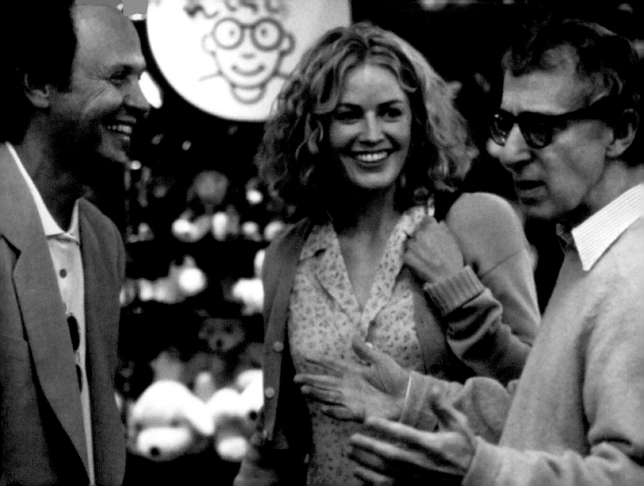

"We actually played basketball together in the '70s, and I was guarding him. He said, 'Don't guard me too close, I tend to get nauseous.'"
—BILLY CRYSTAL

"I always think it is a mistake to try and be young, because I feel the young people in the United States have not distinguished themselves. The young audience in the United States have not proven to me that they like good movies or good theatre."
—WOODY ALLEN

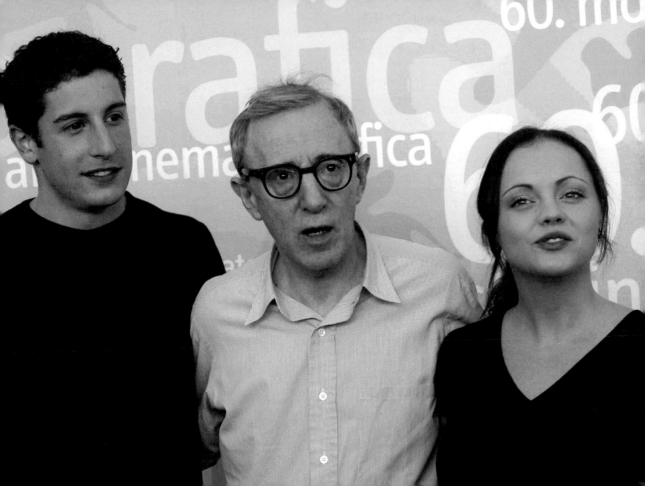

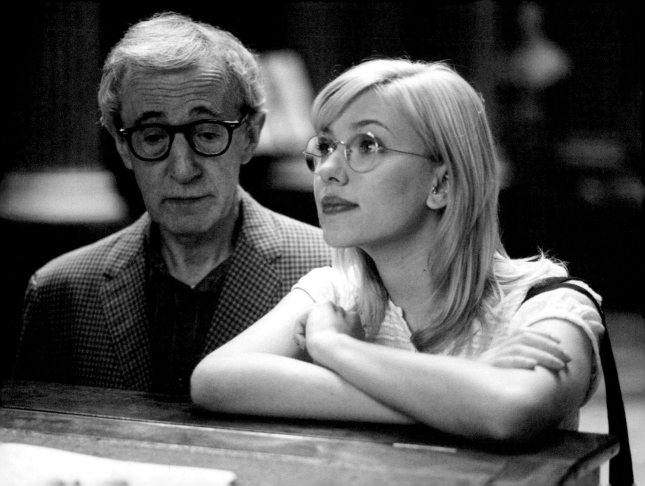

"I grew up on Woody Allen movies. So, for me, working with Woody, that was like 'you made it.'"
—SCARLETT JOHANSSON

On December 24, 1997, Woody Allen and Soon-Yi Previn were married in a civil service in Venice, Italy. The wedding between the sixty-two-year-old Allen and the twenty-seven-year-old Previn was the culmination of their controversial six-year relationship.

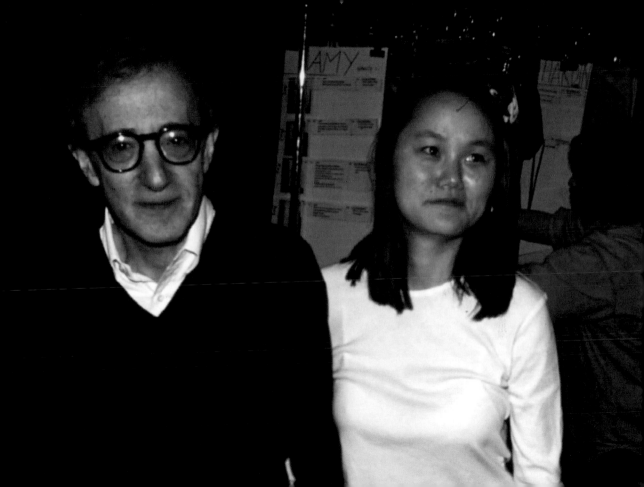

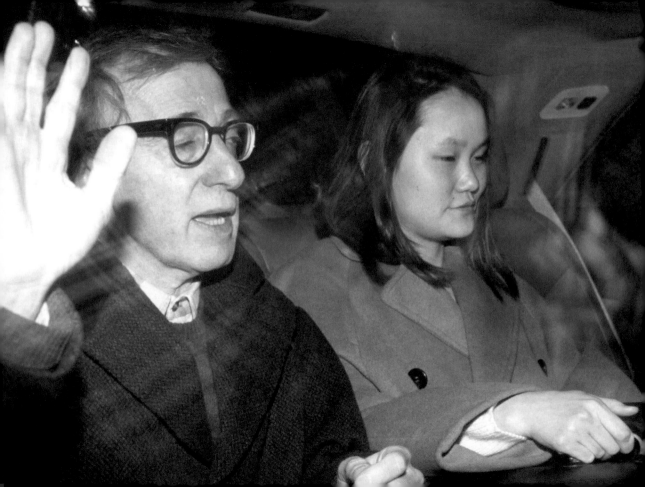

"To think that Woody was in any way a father or stepfather to me is laughable. My parents are Andre Previn and Mia, but obviously they're not even my real parents. I came to America when I was seven. I was never remotely close to Woody. He was someone who was devoted exclusively to his own children and to his work, and we never spent a moment together."
—SOON-YI PREVIN

Woody and Soon-Yi have two adopted daughters, both named after musicians. The first, Bechet, gets her name from clarinetist Sidney Bechet. The second, Manzie Tio, is named for jazz drummer Manzie Johnson and clarinetist Lorenzo Tio.

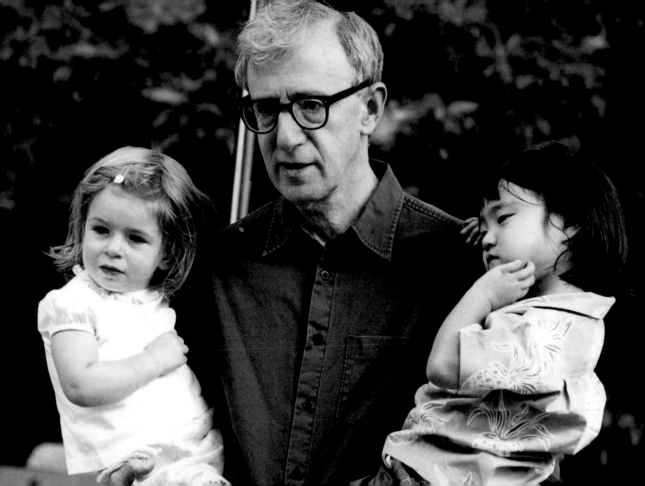

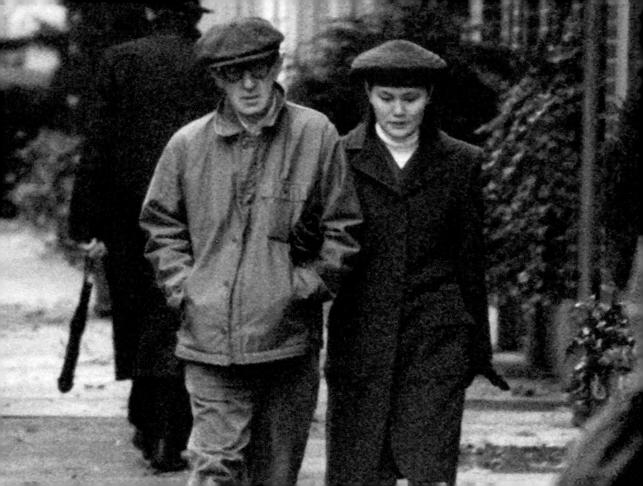

For the documentary *Wild Man Blues* (1997), Allen granted director Barbara Kopple access to his European tour with the Eddy Davis New Orleans Jazz Band. Though the film focused primarily on the music, it also marked the first real behind-the-scenes look at Woody and Soon-Yi's relationship.

"This is Soon-Yi Previn,
the notorious Soon-Yi Previn."
—Allen, introducing Soon-Yi
in *Wild Man Blues*

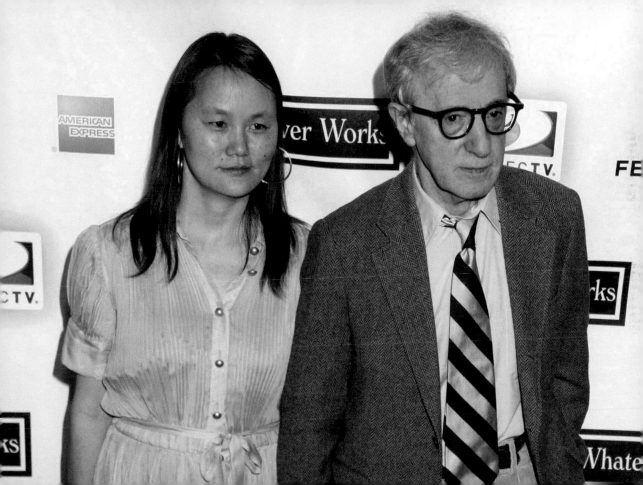

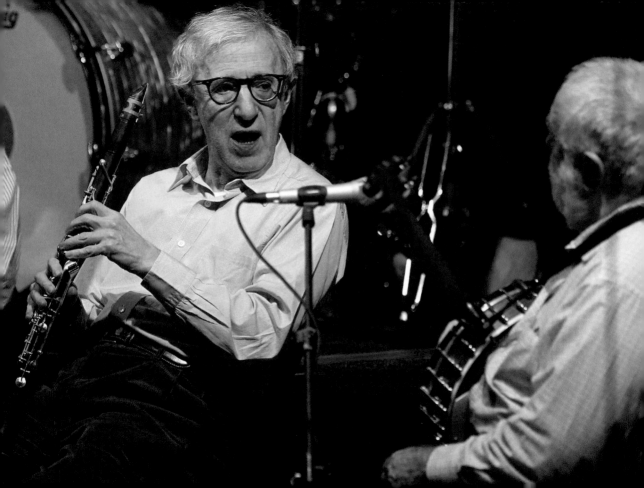

"He loves going to the Carlyle [Hotel] every week and playing music there. He doesn't see it as, 'Ugh, I have to go, it's Monday night.' He loves doing it. And he'll never do anything that he doesn't feel that he can do well."

—LETTY ARONSON, ON ALLEN'S REGULAR CLARINET GIG AT NEW YORK'S CARLYLE HOTEL

"The directors that I have personal, emotional feelings for are Ingmar Bergman and Federico Fellini, and I'm sure there has been some influence but never a direct one. I never set out to try and do anything like them. But, you know, when you listen to a jazz musician like Charlie Parker for years and you love it, then you start to play an instrument, you automatically play like that at first, then you branch off with your own things.
The influence is there, it's in your blood."
—Woody Allen

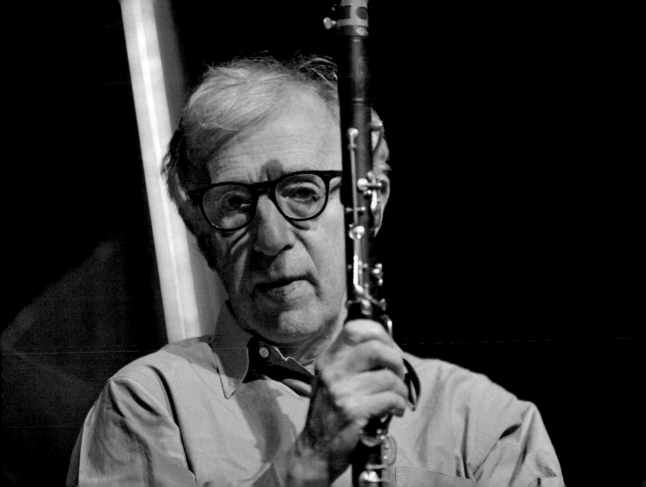

After his initial success with *Take the Money and Run* in the late '60s, Allen pitched a script to United Artists called "The Jazz Baby," which they didn't feel was up to his slapstick standards. When he revisited it almost thirty years later, he did a partial rewrite and turned it into a dramedy about the turbulent life of a talented fictional jazz guitarist named Emmet Ray, casting the volatile actor Sean Penn to play the lead in the film that was now called *Sweet and Lowdown* (1999).

"One day Woody calls 'Cut' and says to me, 'Sean, do you know what was wrong with that take?' Long pause. 'Everything.'"
—SEAN PENN, ON WORKING WITH WOODY ALLEN
ON *SWEET AND LOWDOWN*

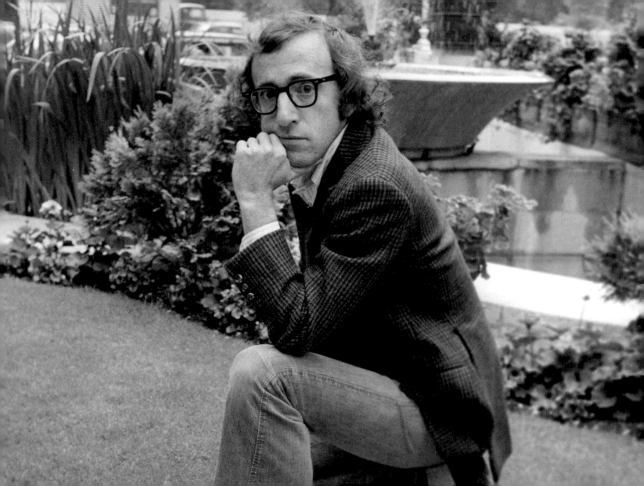

"When I was younger I could have played it,
but I never would have brought to it Sean's
acting skill and his tortured persona."
—WOODY ALLEN, ON SEAN PENN'S ROLE
IN *SWEET AND LOWDOWN*

"Do I want to do what I do uncompromisingly, and would I love it if a big audience came? Yes, that would be very nice. I've never done anything to attract an audience, though I always get accused of it over the years."
—Woody Allen

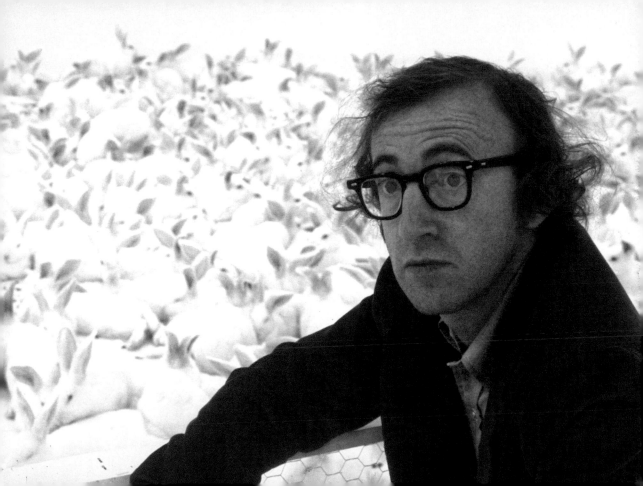

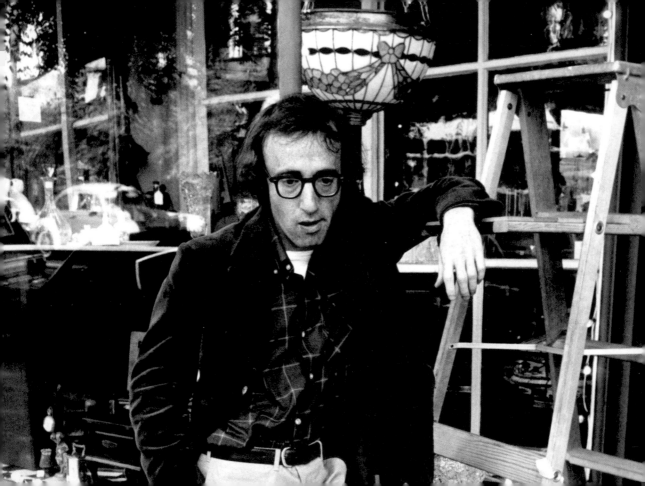

"I never had a teacher who made the least impression on me, and if you ask who are my heroes, the answer is simple and truthful: George S. Kaufman and the Marx Brothers."
—WOODY ALLEN

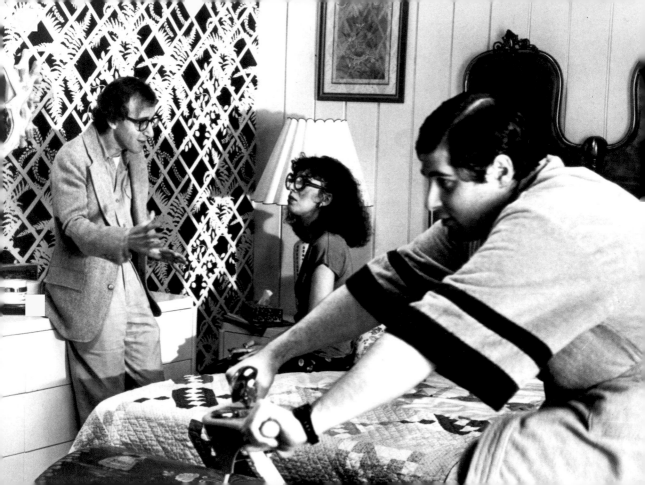

"I get more pleasure out of failing in a project that I am enthused over than in succeeding in a project that I know I can do well."
—WOODY ALLEN

In 2000 and 2001 Allen made back-to-back comic capers. The first, *Small Time Crooks*, had Woody playing a bumbling bank robber who strikes it rich despite his harebrained schemes. The second, *The Curse of the Jade Scorpion,* saw Allen as an insurance investigator who's hypnotized into becoming a jewel thief. Of the two, *Small Time Crooks* was by far the better received, both by critics and audiences.

"I've been around a long time, and some people may just get tired of me, which I can understand. I've tried to keep my films different over the years, but it's like they complain, 'We've eaten Chinese food every day this week.' I want to say, 'Well, yes, but you had a shrimp meal and you had a pork meal and you had a chicken meal.' They say, 'Yes, yes, but it's all Chinese food.'"
—WOODY ALLEN

"He [once] used the phrase, 'I have endless ideas for movies . . .'
I just thought, It would take me a year to have one idea
about a movie, and he's able to think of making
one or two or three or many?"
—DICK CAVETT

Allen is the first to admit that *The Curse of the Jade Scorpion* was not one of his better films. He was particularly critical of his own performance, saying it really wasn't a role he was cut out to play. Apparently he had tried to cast such big name actors as Tom Hanks and Jack Nicholson for the part but eventually had to settle on himself.

"I've never seen anybody write so fast."
—Robert Greenhut, producer

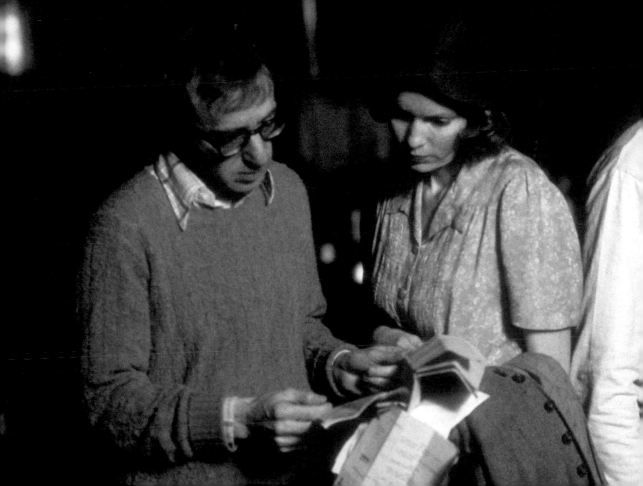

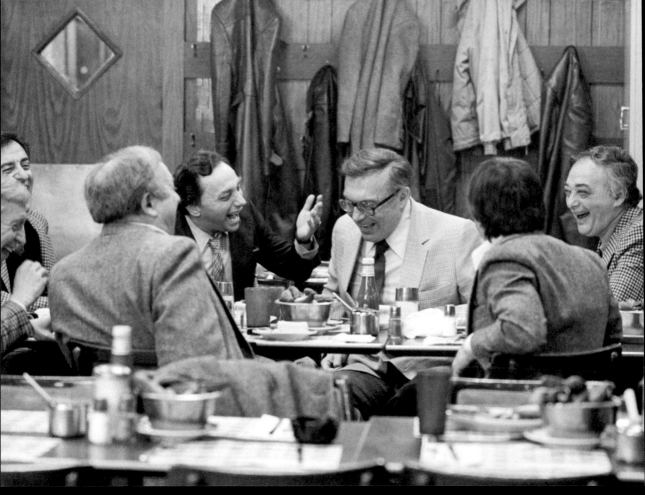

"I'm always seduced by serious stuff. I wish my gift in life had been Tennessee Williams's gift or Ingmar Bergman's or Eugene O'Neill's. It wasn't—my strong point was comedy. Comedy can never go as deep, by its very nature; when a situation becomes tense, you make a joke and it relieves it. These are just personal feelings of mine. Other people don't feel that way."
—WOODY ALLEN

"Now, hopefully, if I make enough films, some of them will come out fresh, but there's no guarantee. It's a crapshoot every time I make one. It could come out interesting or you might get the feeling that, God, I've heard this kvetch before—I don't know."
—Woody Allen

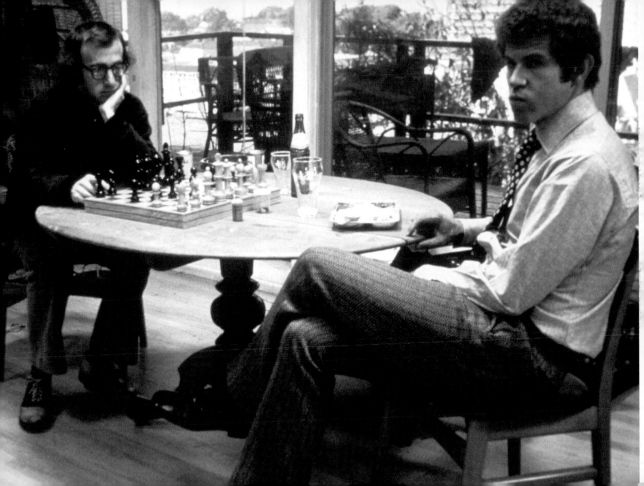

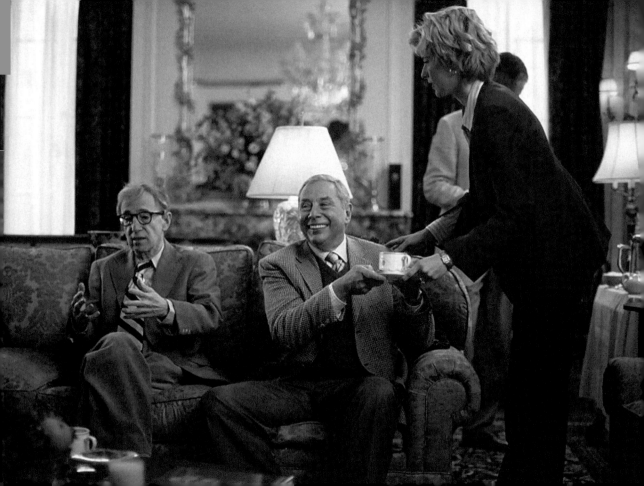

Allen's romantic comedy *Hollywood Ending* opened the 2002 Cannes Film Festival. In the film Allen played a struggling director whose latest effort is a domestic flop but a hit in France. Interestingly enough, the film itself mirrored its plot by doing much better in Europe than it did in the states.

"The biggest personal shock to me of all the movies that I've done
is that *Hollywood Ending* was not thought of
as a first-rate, extraordinary comedy. I was stunned
that it met with any resistance at all."
—WOODY ALLEN

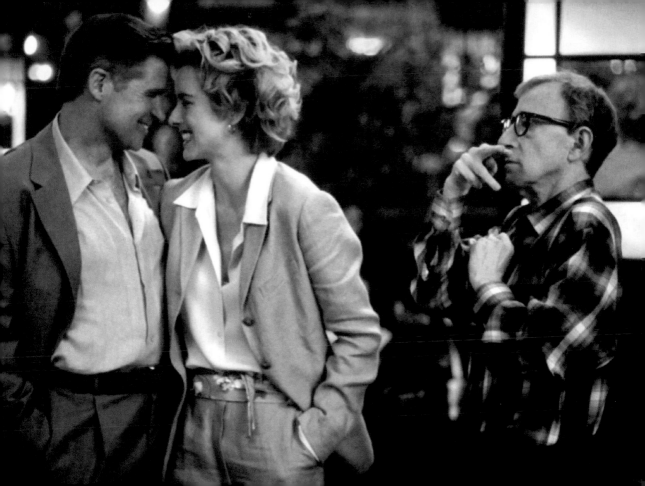

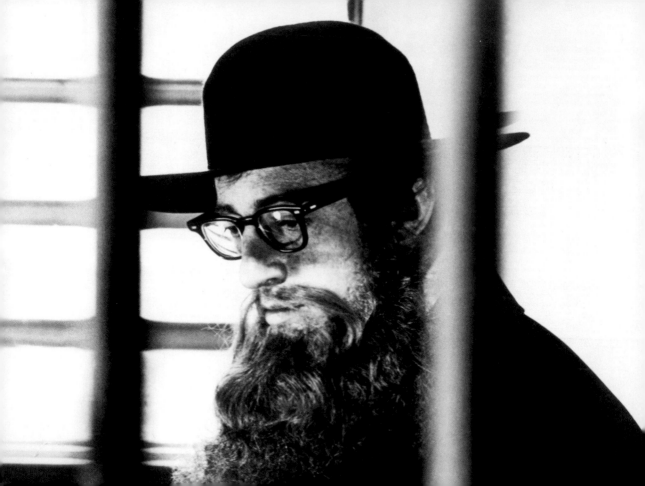

"To me, there's no real difference between a fortune teller or a fortune cookie and any of the organized religions. They're all equally valid or invalid, really. And equally helpful."
—WOODY ALLEN

"If Woody Allen were a Muslim, he'd be dead by now."
—SALMAN RUSHDIE

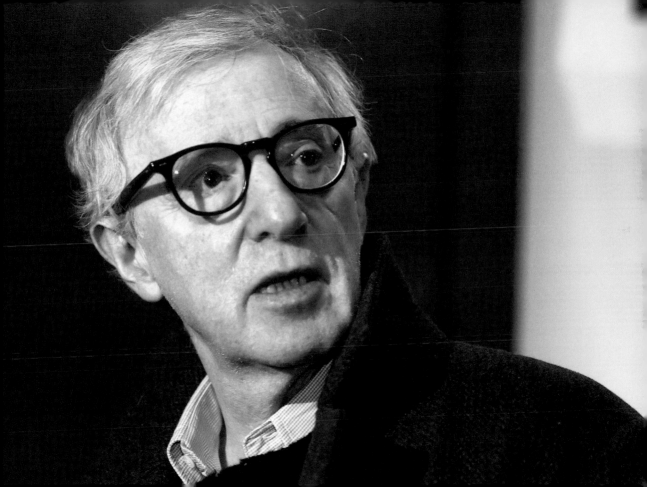

"Who the hell is good for twenty years?
This guy's been good for forty years!"
—CHRIS ROCK

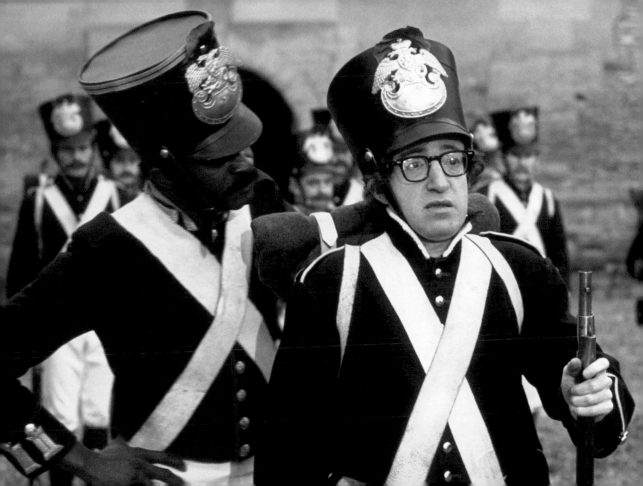

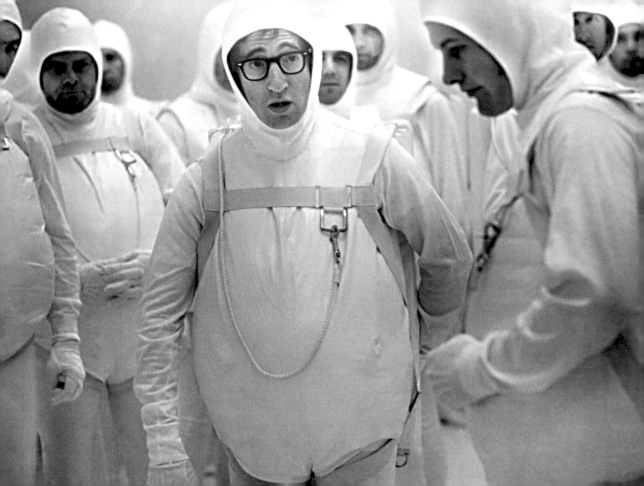

"I could make ten movies in a row that would be as serious as *INTERIORS* or as light as *SMALL TIME CROOKS*. There's no way of me knowing. I'm just happy to get any ideas."
—WOODY ALLEN

"I was in love with him before I knew him. He was Woody Allen. Our entire family used to gather around the TV set and watch him on Johnny Carson. He was so hip, with his thick glasses and cool suits."
—DIANE KEATON

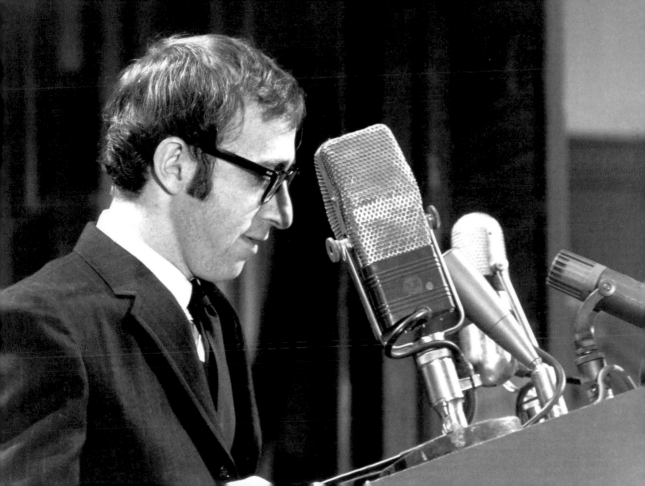

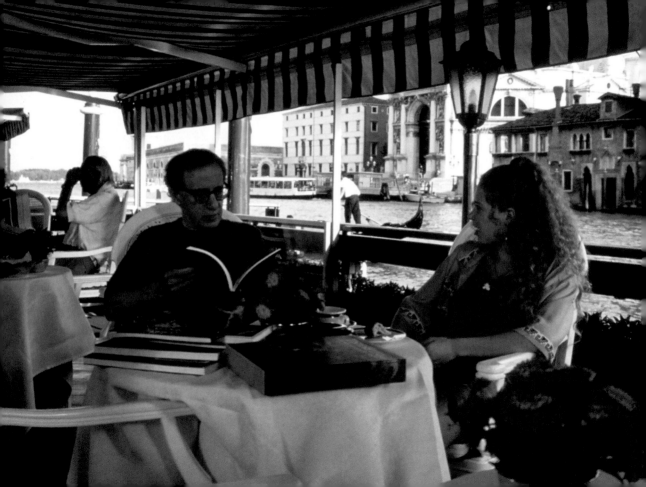

Allen has been known to jot down movie ideas on scraps of paper,
matchbook covers, basically anything he can write on.
He keeps all of these papers in a drawer in his home and,
when it's time to start a new script, sifts through them to see
which concept appeals to him at that time.

"I'm a practicing heterosexual, although bisexuality immediately doubles your chances for a date on Saturday night."
—WOODY ALLEN

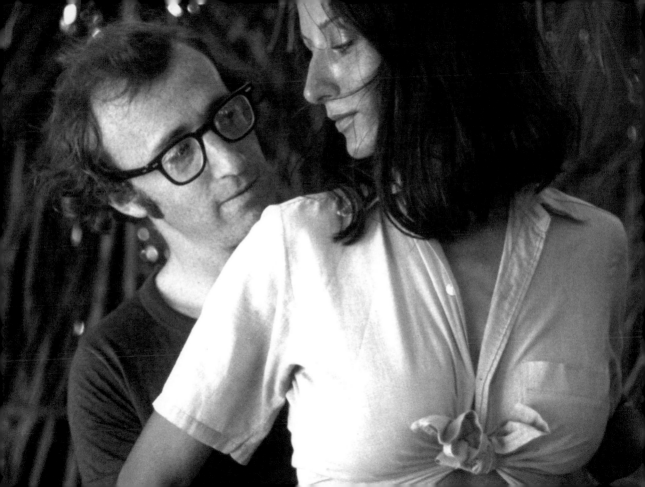

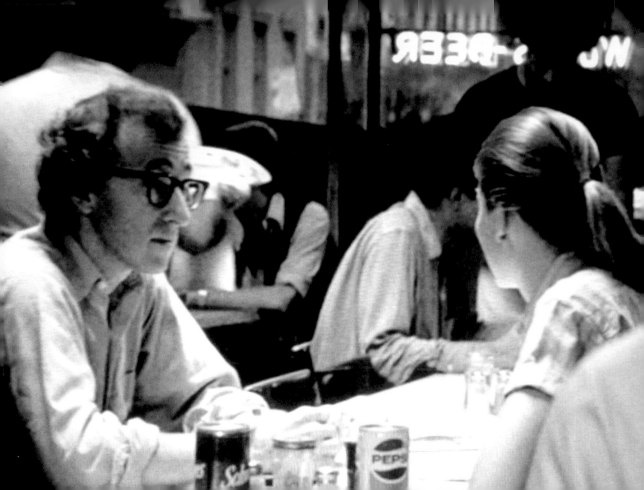

"He's a romantic. He's a mush."
—Mariel Hemingway

"Having sex is like playing bridge. If you don't have a good partner, you'd better have a good hand."
—WOODY ALLEN

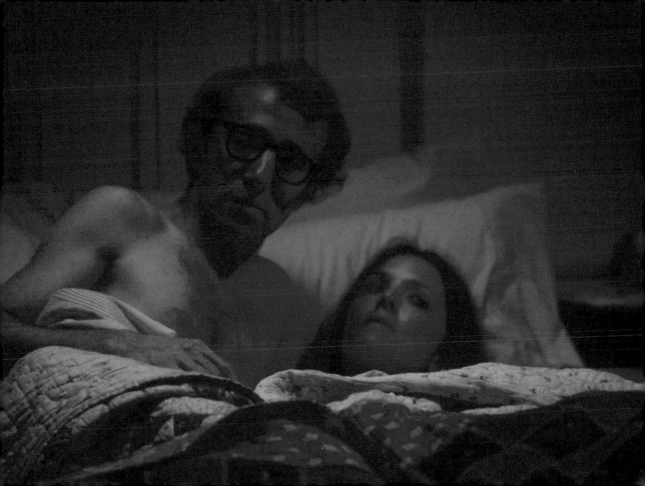

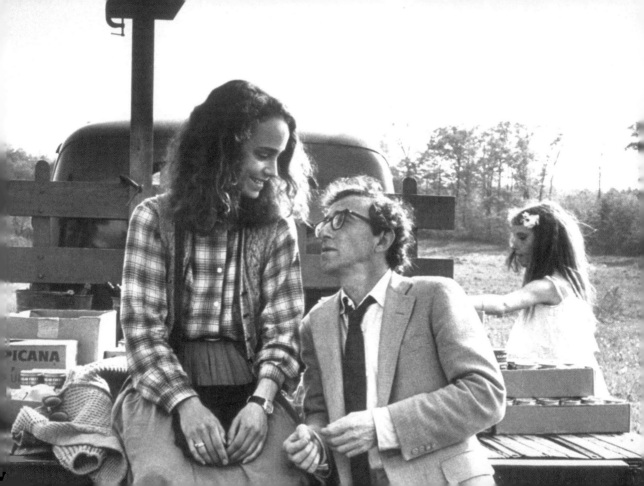

In 1995 Allen cracked *Empire* magazine's list of the 100 Sexiest Stars in Film History, coming in at #89.

"Woody does have a very typical New York sense of humor. Early on in rehearsals, he was breaking the ice with me and he said, 'So, I hear you still have flying carpets and snake charmers in India.' And I looked at him and then I realized that he was kidding. I said, 'Woody, I think you've got the wrong city. I think you're talking about New York!' I feel that sometimes people didn't get his humor. I think they thought it was rude. But I got it. I think it's funny.
—FREIDA PINTO

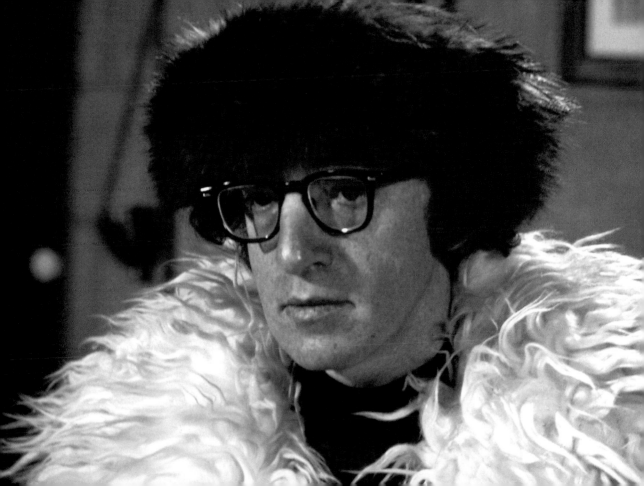

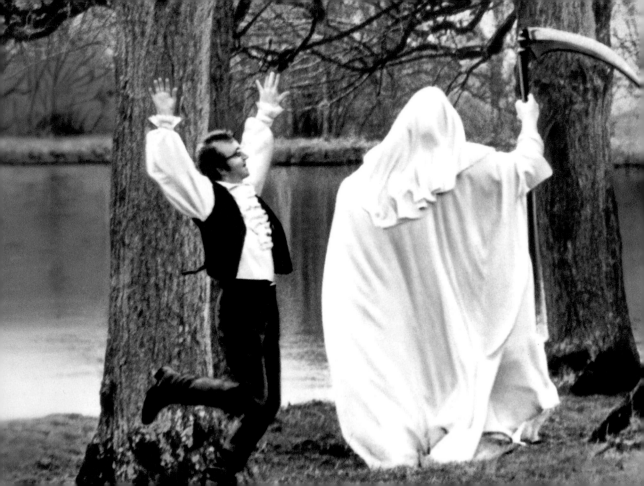

"I hate to go to the country. I mean, it's a bore. You go for a weekend and there's nothing. You can't go out in the street and buy a paper. You can't go to a bookstore at midnight. There's nothing to do. You just sit around, right? Meanwhile, everybody's talking about how great the country is."
—WOODY ALLEN

"A guy like Steven Spielberg will go live in the desert to make a movie, or Martin Scorsese will make a picture in India and set up camp and live there for four months. I mean, for me, if I'm not shooting in my neighborhood, it's annoying. I have no commitment to my work in that sense. No dedication."
—WOODY ALLEN

Though born in the Bronx and raised in Brooklyn, Woody Allen has spent most of his life living on the island of Manhattan. His first residence was a very modest single-room apartment which he rented for $125 a month. He now lives a bit more extravagantly on Manhattan's Upper East Side.

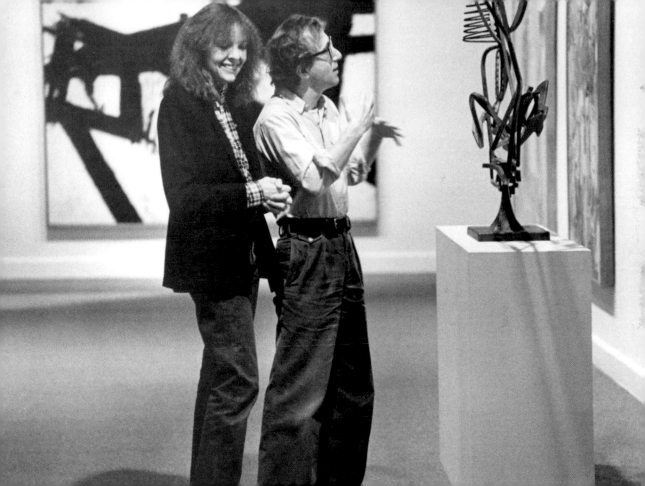

"For some reason I've always had
an irrational love for New York."
—Woody Allen

"He loves New York so much. I mean, it's his city."
—Mariel Hemingway

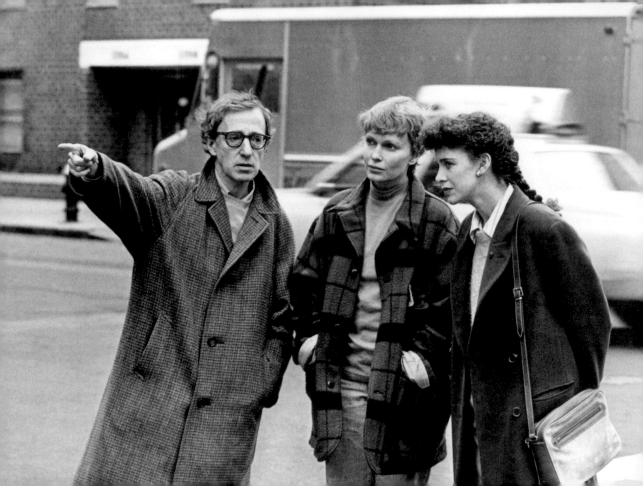

"I was living in a sublet on Madison Avenue, and every night you would hear ambulances and sirens. It was truly a lullaby."
—WOODY ALLEN

Allen flew to Europe just days after the September 11th attacks.
Once there, he found himself invited on television news shows
in various countries where he acted as a sort of
spokesman for New York.

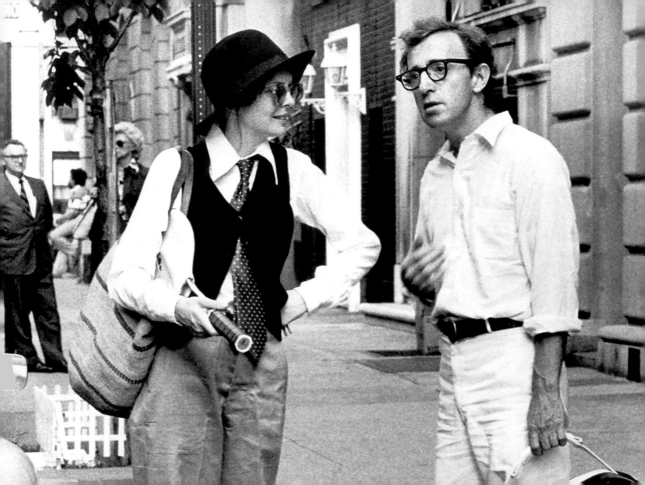

"I felt New York would metabolize it, and it would go on.
New York would be the same vibrant city. And it is.
—Woody Allen, on the aftermath of
the September 11th attacks

"When you travel around the country, you see what a tough town New York is: rude, competitive, a town where good, logical ideas are ignored in favor of unworkable ones. And yet, all these other towns are so dead and boring compared to New York."
—WOODY ALLEN

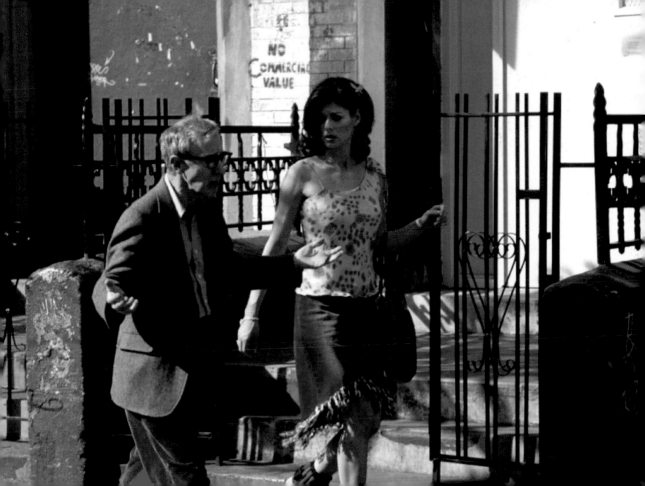

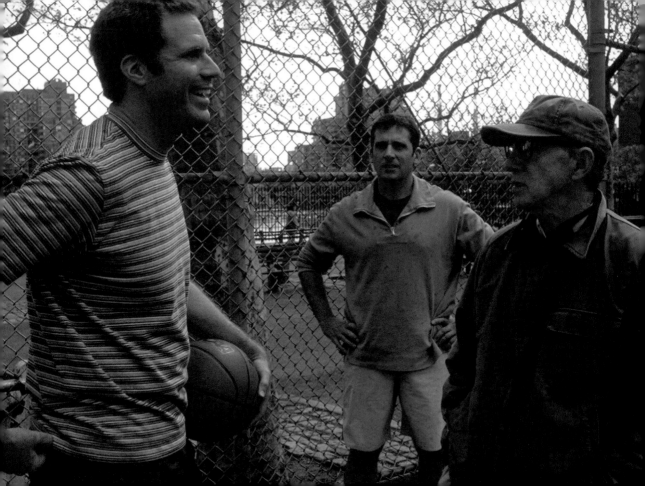

After several years of what some Allen fans would call cinematic missteps, including the 2003 comedy *Anything Else*, Woody bounced back in the eyes of many with the quirky dramedy *Melinda and Melinda* (2005). The film featured actress Radha Mitchell essentially playing two versions of the same character, one whose life plays out like a lighthearted comedy and the other far more dark and dramatic. Included in the ensemble cast were two men who had cut their teeth on television comedy, Will Ferrell and Steve Carell.

"Most of life is tragic. You're born, you don't know why. You're here, you don't know why. You go, you die. Your family dies. Your friends die. People suffer. People live in constant terror. The world is full of poverty and corruption and war and Nazis and tsunamis. The net result, the final count is, you lose—you don't beat the house."
—WOODY ALLEN

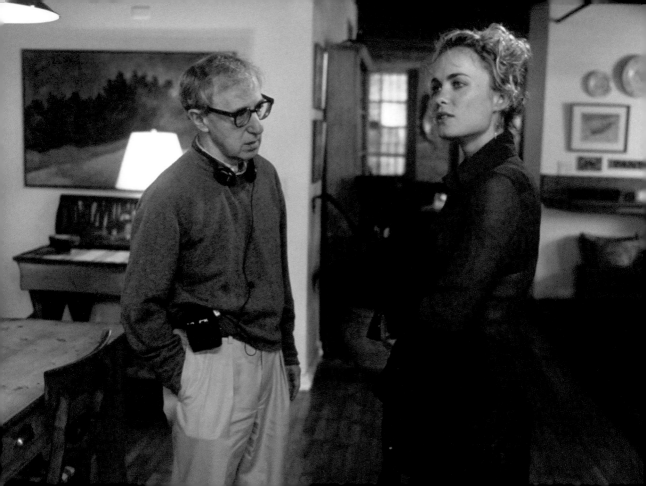

"It was kind of scary because working with Woody Allen becomes sort of a big deal in your mind. He directs in that Woody Allen character some of the time—he has these idiosyncrasies that are really charming and funny."
—RADHA MITCHELL

"I loved the structure of the whole movie—these two parallel stories which were illustrating the point of the fine line between comedy and tragedy. It was so imaginative and unique but at the same time very signature Woody Allen."
—WILL FERRELL, ON *MELINDA AND MELINDA*

Woody Allen holds the record for most Original Screenplay Oscar nominations, with fourteen. He's won the award twice, for 1977's *Annie Hall* and 1986's *Hannah and Her Sisters*. Overall he's been nominated for an astounding twenty-one Academy Awards, receiving an additional six for directing and one for acting, again in *Annie Hall*.

"I know it sounds horrible, but winning that Oscar for
Annie Hall didn't mean anything to me."
—WOODY ALLEN

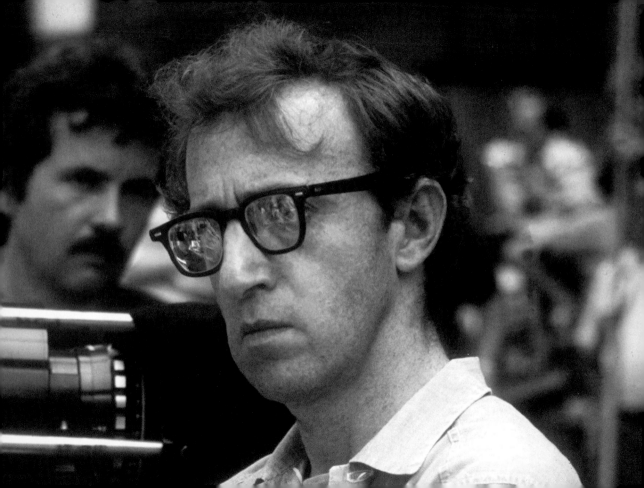

"Woody Allen sets are very quiet. Extraordinary sense of power from a man who doesn't do anything except just stand there."
—F. Murray Abraham

"The films that are made for young people are not wonderful films, they are not thoughtful. They are these blockbusters with special effects. The comedies are dumb, full of toilet jokes, not sophisticated at all. And these are the things that young people embrace. I do not idolize the young."

—WOODY ALLEN

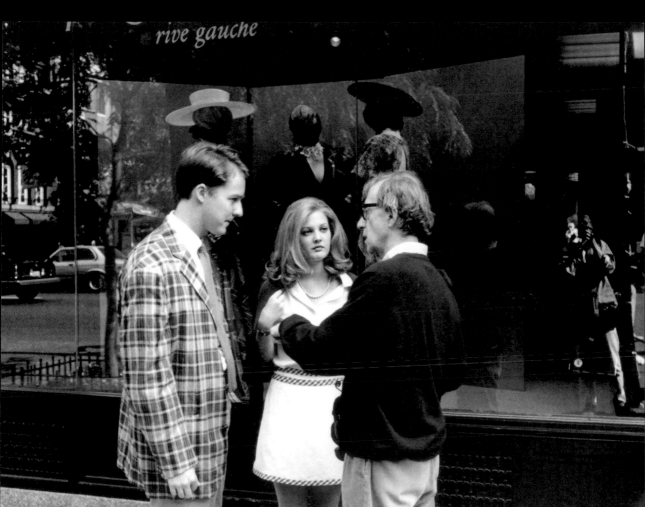

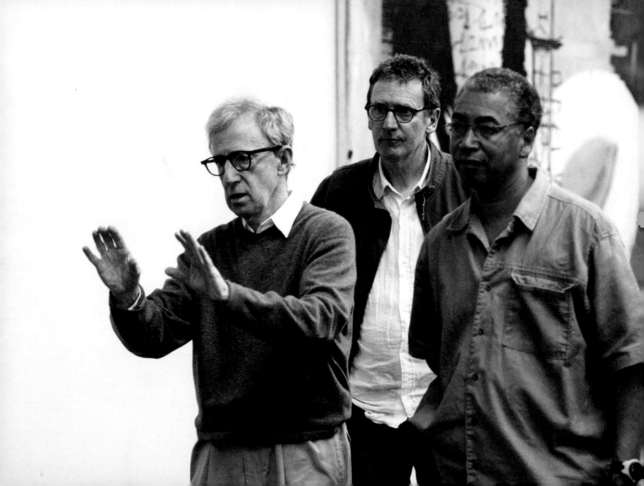

Match Point (2005) was quite a departure for Allen, both literally and figuratively. For starters, he left his comfort zone of New York and shot the entire movie in and around London. Also, instead of continuing his string of comedies, this film was a straight dramatic thriller. It proved to be both a critical and financial success and quieted the whispers that perhaps Woody was washed up.

"I wasn't away. And I'm not back. *Match Point* was a film
about luck, and it was a very lucky film for me. I did it the way
I do all my pictures, and it just worked. I needed a rainy day,
I got a rainy day. I needed sun, I got sun. Kate Winslet dropped
out at the last moment because she wanted to be with her family,
and Scarlett Johansson was available on two days' notice.
It's like I couldn't ruin this picture no matter how hard I tried."
—WOODY ALLEN

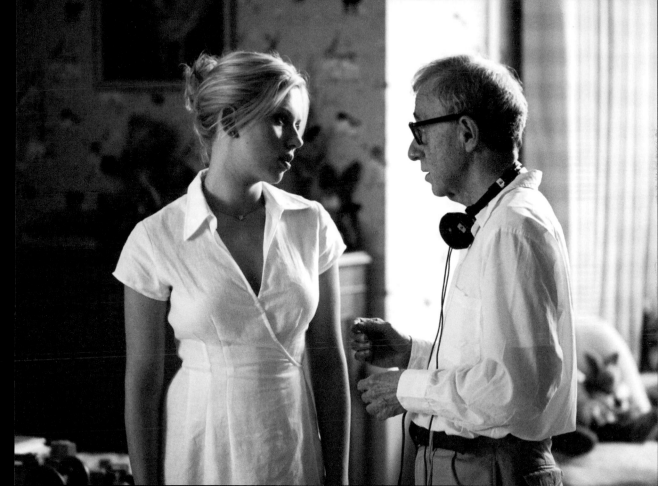

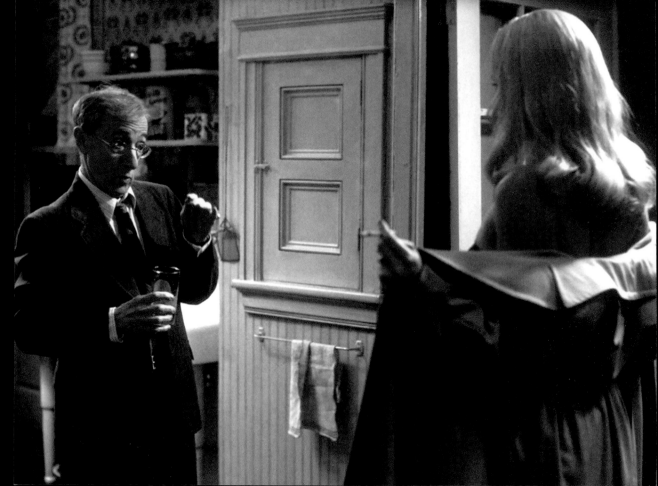

"If you're not in the mood for my obsessions, then you may not be in the mood for my film."
—WOODY ALLEN

After the unexpected success of *Match Point*, Allen shot his next
two pictures, *Scoop* (2006) and *Cassandra's Dream* (2007)
in England. For the comic mystery *Scoop*, Woody
once again tabbed Scarlett Johansson to play
the female protagonist. This led many to think that
Allen had found a new muse for his scripts in the same way
he had with Diane Keaton and Mia Farrow.

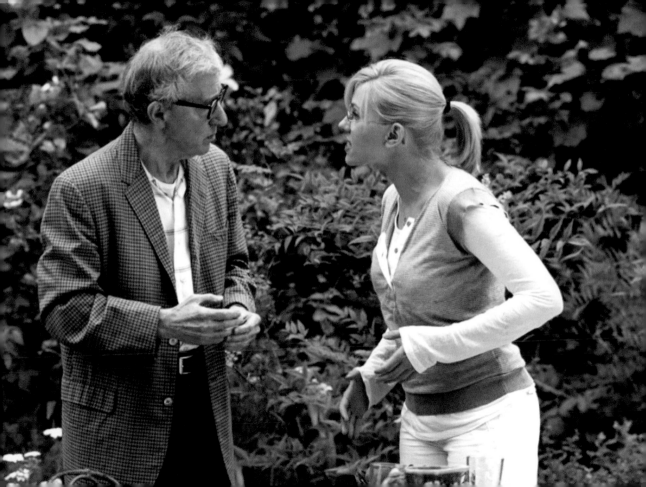

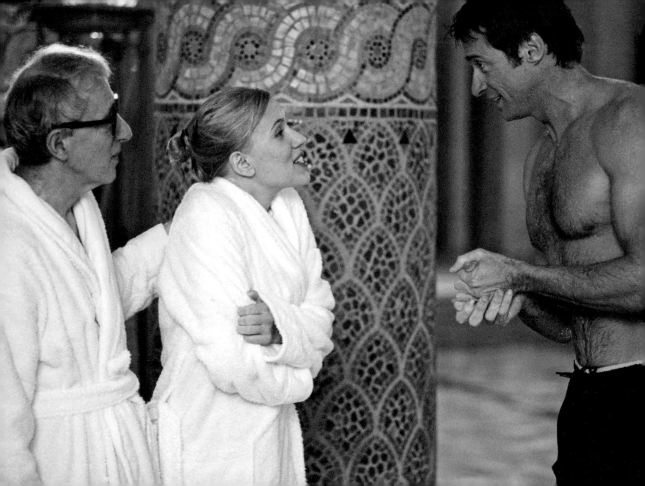

"It is silly—she's in no way my muse, but she is one of the great American actresses."
—WOODY ALLEN, ON SCARLETT JOHANSSON

"He's cripplingly shy."
—Scarlett Johansson

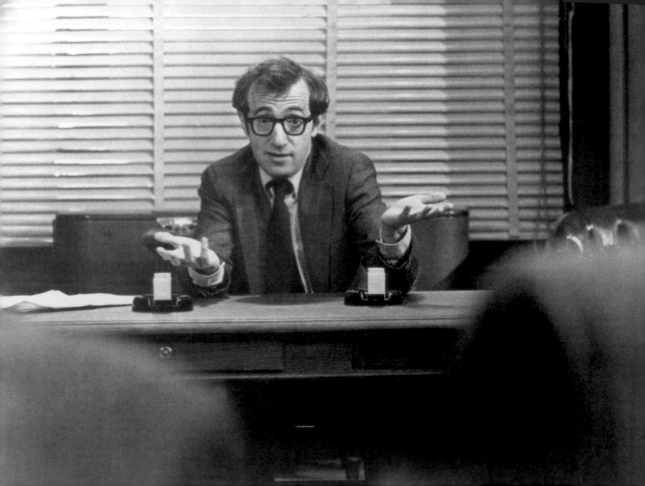

"In the United States things have changed a lot, and it's hard to make good small films now . . . They only want these $100-million pictures that make $500 million. That's why I'm happy to work in London, because I'm right back in the same kind of liberal creative attitude that I'm used to."
—WOODY ALLEN

Allen has a longstanding reputation as a "hands-off director" who likes to give his actors the freedom to define their own characters and even deviate from the script and ad-lib lines if something feels right to them. The flip side of this directing style is that he offers very little in the way of notes or comments during a shoot, so the cast is never quite sure what Woody thinks about their performances.

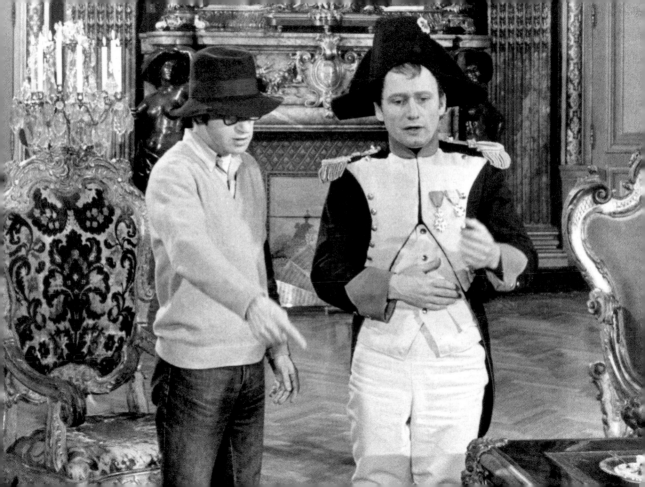

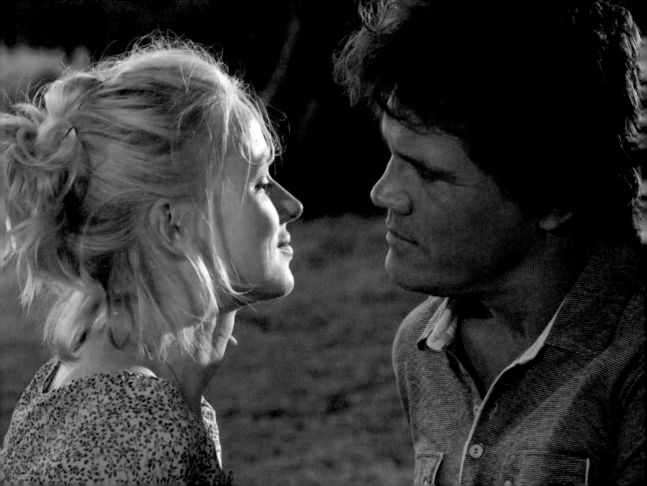

"You really want to please him."
—JOSH BROLIN

"To this day, I've never heard him make a specific comment about the character that I played."
—SEAN PENN, ON HIS PERFORMANCE
IN *SWEET AND LOWDOWN*

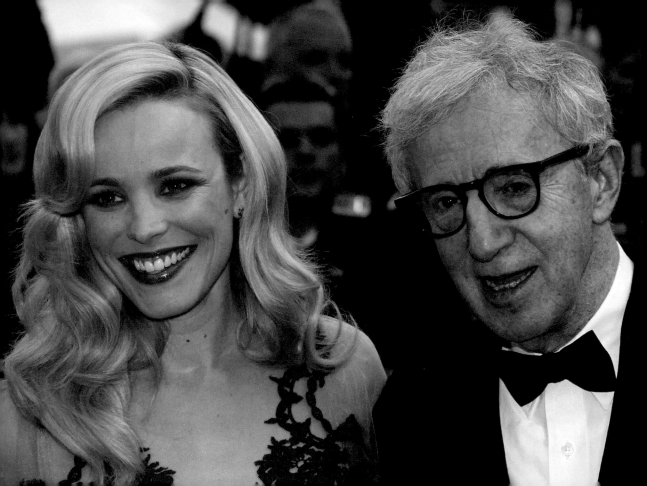

"It's true that he does give his actors a lot of freedom. Which I think is nice, you know, that he trusts the people he casts."
—Rachel McAdams

"I grew up in what they called the Golden Age of Movies. Really, it was the golden age of movie stars. William Powell and Fred MacMurray and Edward G. Robinson. The stars had some kind of charismatic hold that later stars don't have."

—Woody Allen

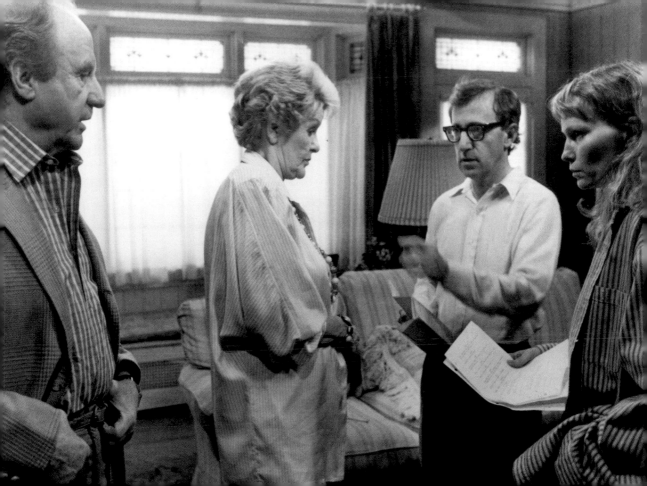

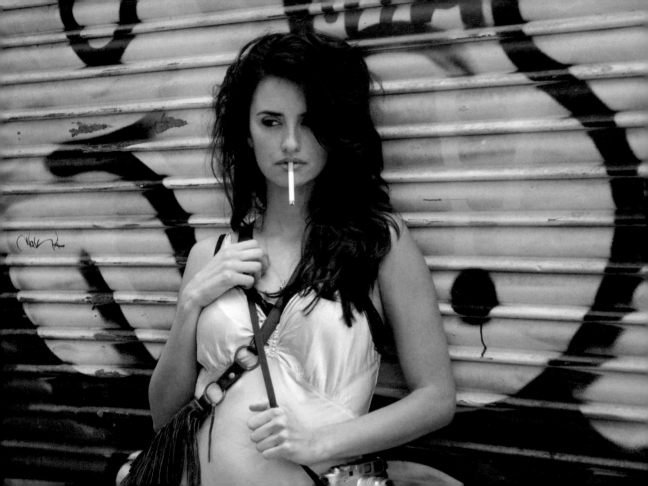

In 2008 Allen proved to be a good luck charm to yet another one of his supporting actresses, as Penelope Cruz won an Oscar for her portrayal of the sexy but unstable Maria Elena in *Vicky Cristina Barcelona*. Set in Spain, it was Woody's fourth consecutive film shot in Europe, a long time working abroad for a guy who rarely liked to leave New York.

"*Vicky Cristina Barcelona* is a better film than those I made years ago. But it's capricious. I get an idea for a film and I do it, and if I'm right in my judgment, and in execution, then the film turns out to be a good film, a step forward. If I guessed wrong and I thought the idea was wonderful and it's really not, or I execute badly, then the film is not such a good film. But it doesn't have anything to do with the chronology."
—WOODY ALLEN

"I can't wait to be around him again, because he makes me laugh so much."
—PENELOPE CRUZ, ON THE PROSPECT OF WORKING WITH ALLEN AGAIN

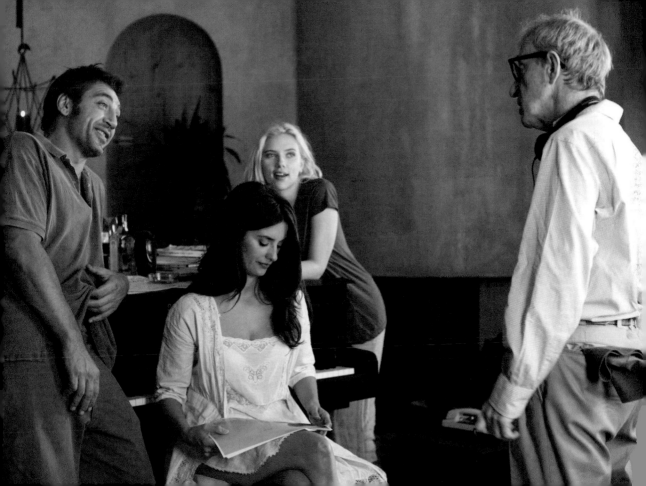

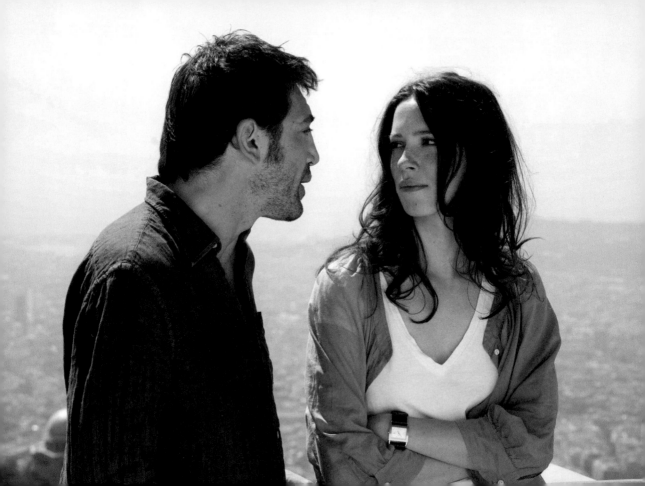

"There's an excitement because I think he's a genius, but there's also the fear of making his work look bad. The excitement also comes from knowing that you have brilliant dialogue coming out of your mouth like jewels."
—JAVIER BARDEM, ON WORKING WITH WOODY ALLEN

In a 2010 interview with the *London Times*, Allen listed his six favorite Woody Allen films as *The Purple Rose of Cairo*, *Match Point*, *Bullets Over Broadway*, *Zelig*, *Husbands and Wives*, and *Vicky Cristina Barcelona*.

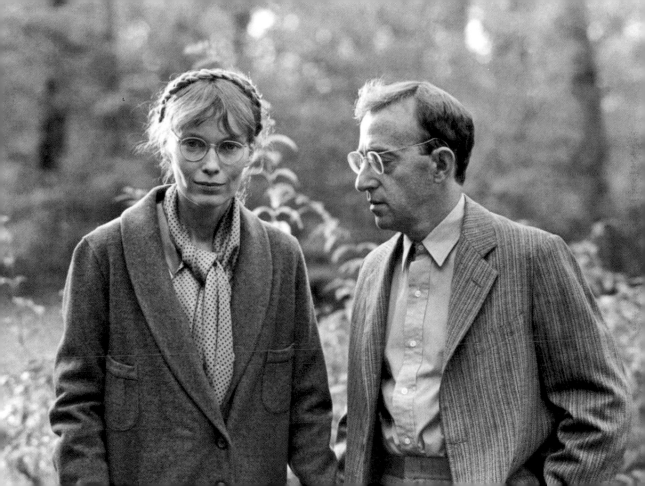

"He has great respect for us actors, and there is a euphoria when you get those big takes. There's a payoff to it."
—PATRICIA CLARKSON

"Well, I'm against [the aging process]. I think it has nothing to recommend it. You don't gain any wisdom as the years go by. You fall apart, is what happens. People try and put a nice varnish on it, and say, well, you mellow. You come to understand life and accept things. But you'd trade all of that for being thirty-five again."
—WOODY ALLEN

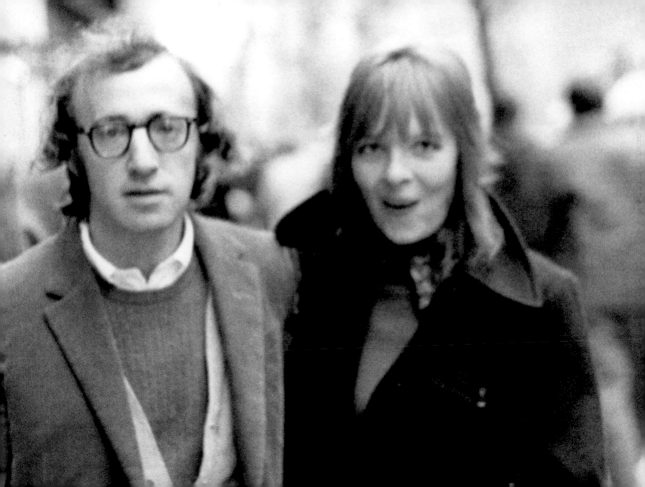

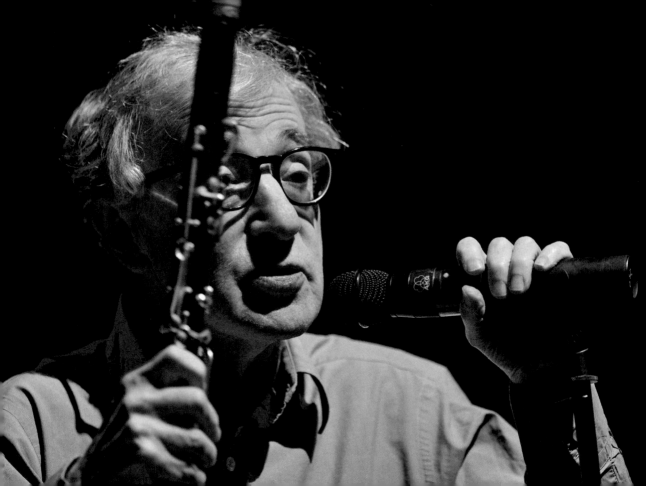

"He said to me that if he could do anything in the world
he would have loved to have been a clarinet player,
more than a filmmaker."
—Juliet Taylor

It's well known that Allen is a big sports fan, especially when it comes to his beloved New York Knicks. A longtime season ticket holder, Woody has a reputation for speeding things along on the set or cutting shoots short due to the fact that there's a Knicks game he either needs to get to or watch on TV.

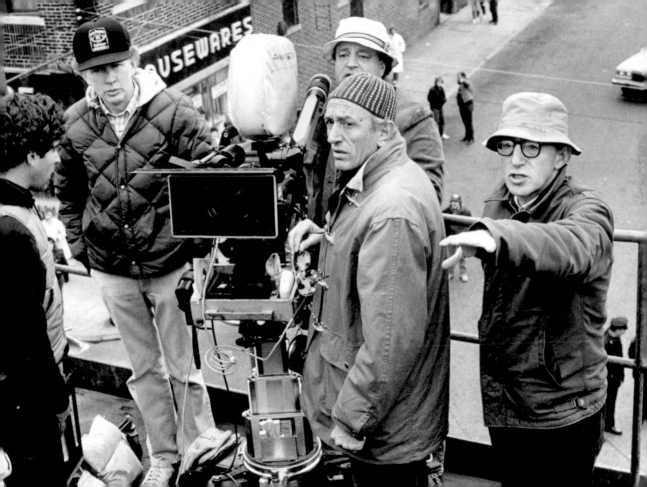

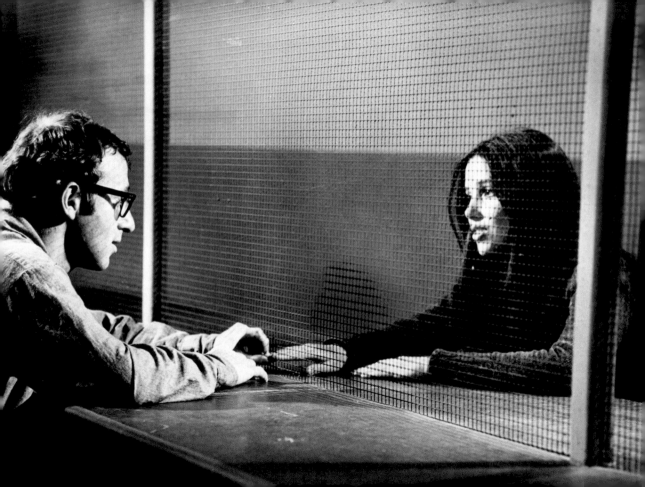

"The only thing standing between greatness and me, is me."
—WOODY ALLEN

"How can you get too caught up in reviews or how the movie's doing if you're already on to your next movie?"
—Owen Wilson, on Allen's film-a-year work schedule

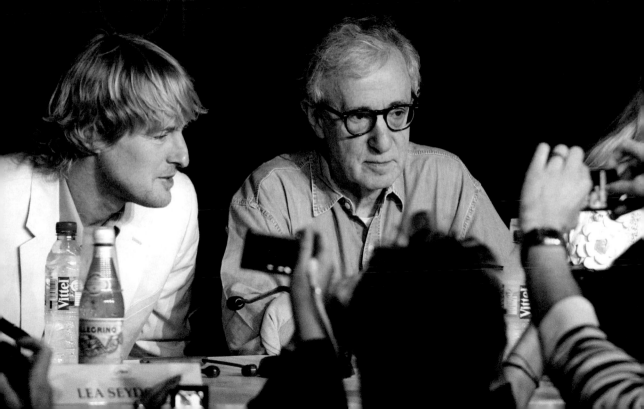

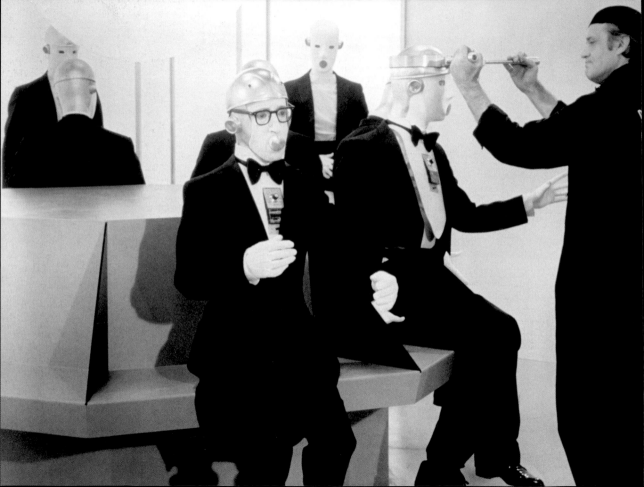

"My brain: It's my second favorite organ."
—WOODY ALLEN

Though he's clearly had his ups and downs with women over the years, there is no denying that Allen has a talent for writing female characters and dialogue. As of 2011, five of his films have sent actresses home with Oscars: Diane Keaton (*Annie Hall*), Dianne Wiest (*Hannah and Her Sisters* and *Bullets Over Broadway*), Mira Sorvino (*Mighty Aphrodite*), and Penelope Cruz (*Vicky Cristina Barcelona*).

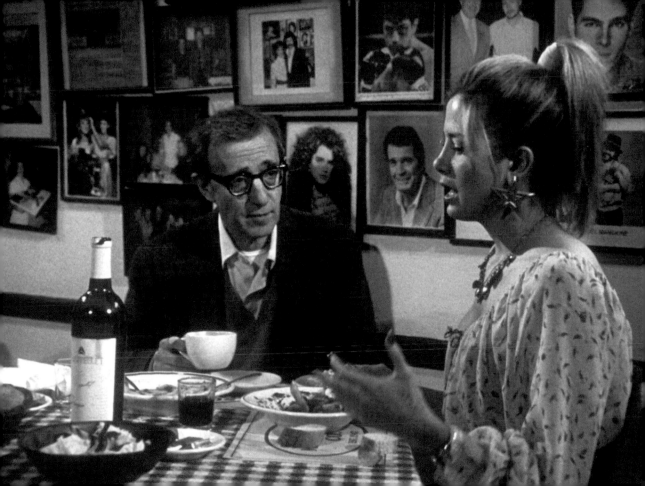

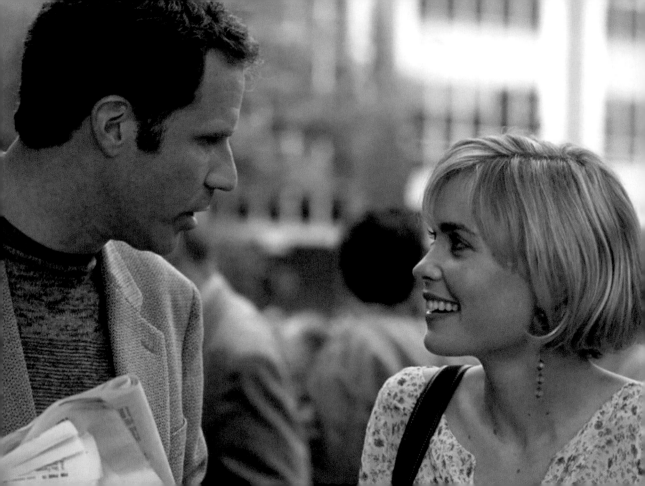

"Well, obviously I was excited by the idea that Woody Allen was going to direct it. But at the same time, the script itself and the character were really interesting."
—RADHA MITCHELL, ON HER ROLE IN *MELINDA AND MELINDA*

"He loves women. He appreciates women. He has written some of the best female characters of all time. And I love how well he knows neurotic women."
—PENELOPE CRUZ

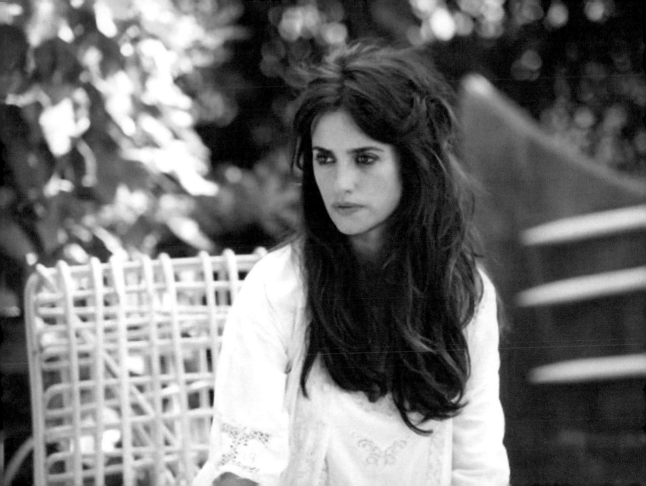

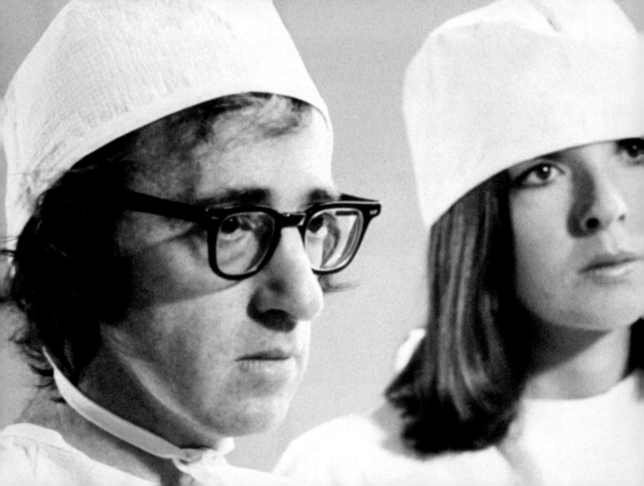

"I was his endearing oaf. I had him pegged as a cross between a 'White Thing' and the cockroach you couldn't kill."
—DIANE KEATON

Most of Woody Allen's movies have enjoyed only modest box-office success, if any. When the US studios, who once gave him free rein, began asking for more involvement in the creative process, he started filming in Europe. In Europe he was once again able to work with people who put up the money —with no questions asked.

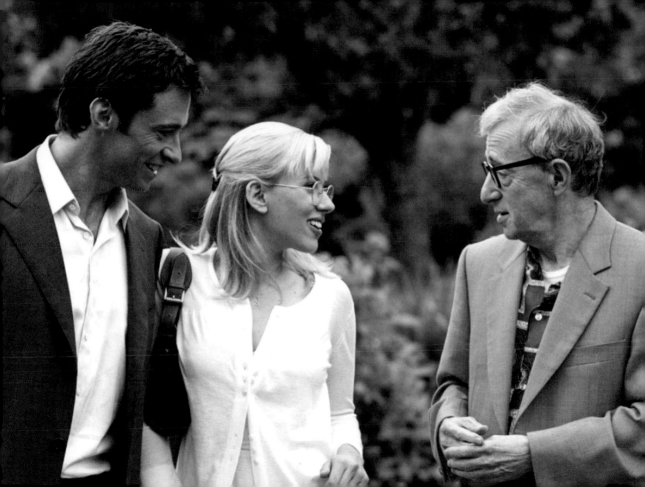

"How many great films has he made? A lot.
So he's made a few clunkers. But even the clunkers,
there's always something about them, always.
That's art."
—MARIEL HEMINGWAY

"He once said to me [after a take],
'It wasn't horrible.'"
—LARRY DAVID

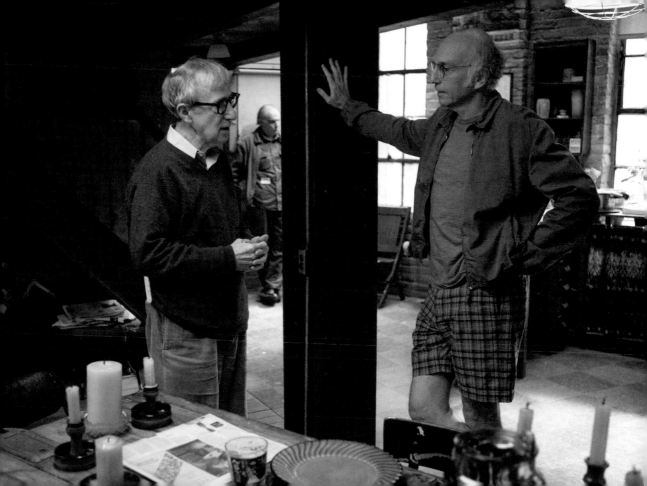

"People would say to me, 'oh, it's just a crutch.'
And I would say, 'yes. It's a crutch, and exactly what I need
in this point in my life is a crutch.'"
—WOODY ALLEN, ON PSYCHOANALYSIS

Allen still types all of his screenplays on the same Olympia manual typewriter he's used for years. While he's comfortable working on this dated machine, he still admits to being a bit helpless when it comes to changing the typewriter's ribbon and occasionally will ask a friend to do it for him.

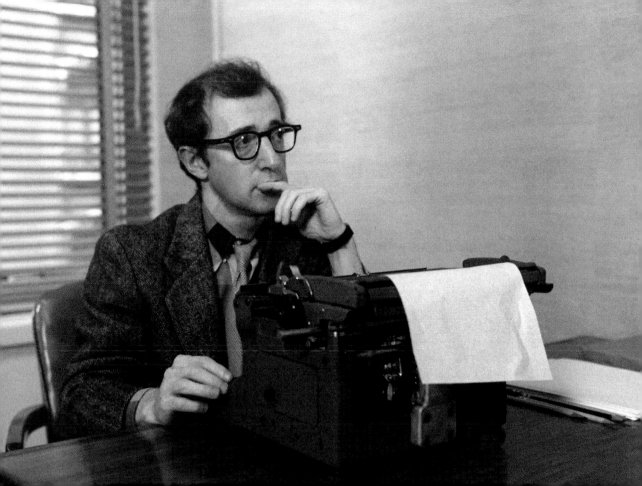

"I don't own a computer, have no idea how to work one, don't own a word processor, and have zero interest in technology."
—WOODY ALLEN

"He's not afraid to fail. He kind of approaches it like a baseball player. Like, 'Okay, I'll get 'em the next time.'"
—CHRIS ROCK

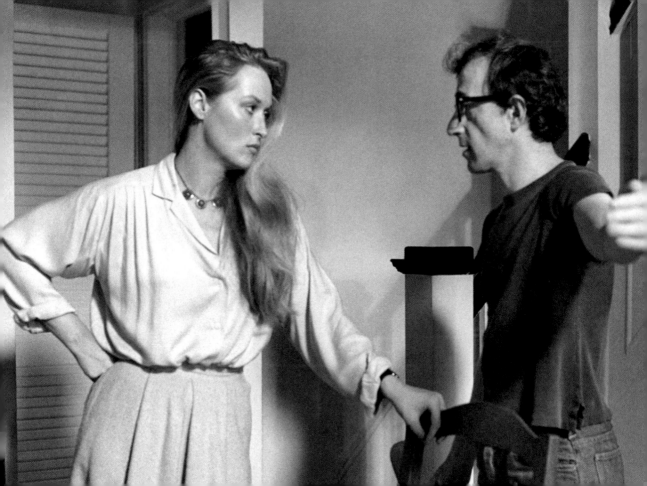

"I've made perfectly decent films, but not *8½*, not
The Seventh Seal, *The 400 Blows,* or *L'Avventura*—films that,
to me, really proclaim cinema as art, on the highest level.
If I was the teacher, I'd give myself a B."
—Woody Allen

"We had an identifiable repartee. When they
[the audience] see intimacy, it was real."
—TONY ROBERTS, ON HIS ON-SCREEN CHEMISTRY WITH ALLEN

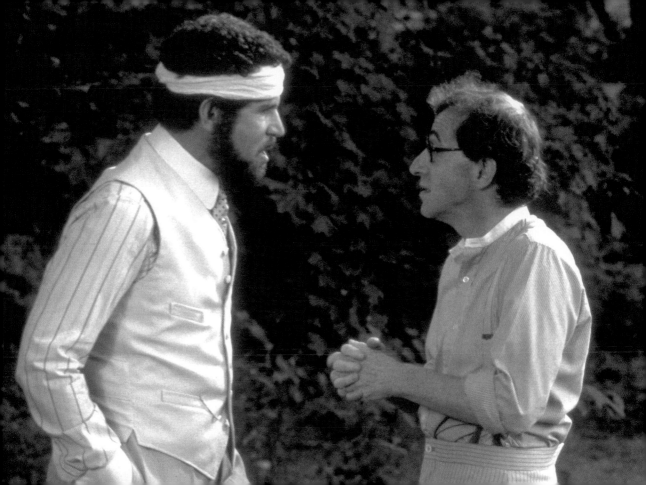

Allen has written, directed, and often starred in at least one feature-length movie each year since 1982's *A Midsummer Night's Sex Comedy.* This breakneck schedule doesn't even include other projects such as plays, short stories, and the occasional television project.

"Retire and do what? I'd be doing the same thing I do now: sitting
at home writing a play, then characters, jokes,
and situations would come to me. So I don't know
what else I would do with my time."
—WOODY ALLEN

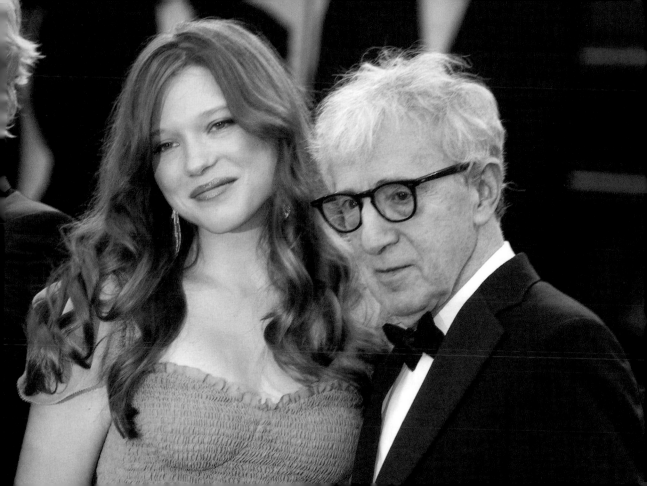

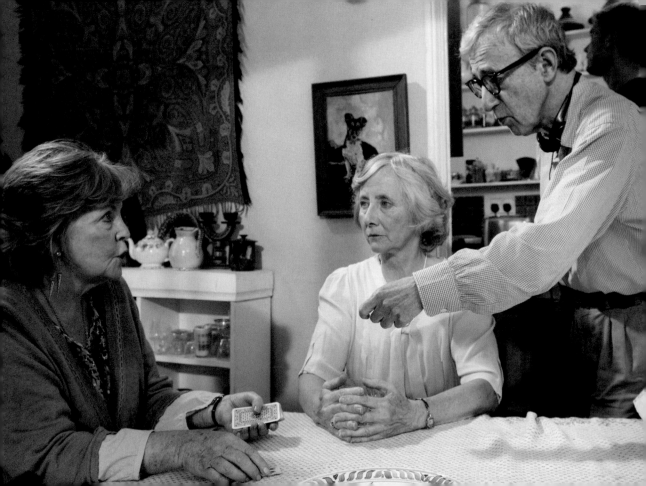

"The only folk I can judge are people like Woody Allen who I think is a genius, largely because I think he has beaten the system. He has his own company, and his films are all his own ideas. It's his direction, and so it comes out the way he imagined it."
—Nigel Neale

"I think it's got to a point where everyone wants to do a Woody Allen movie before they die."

—JULIET TAYLOR

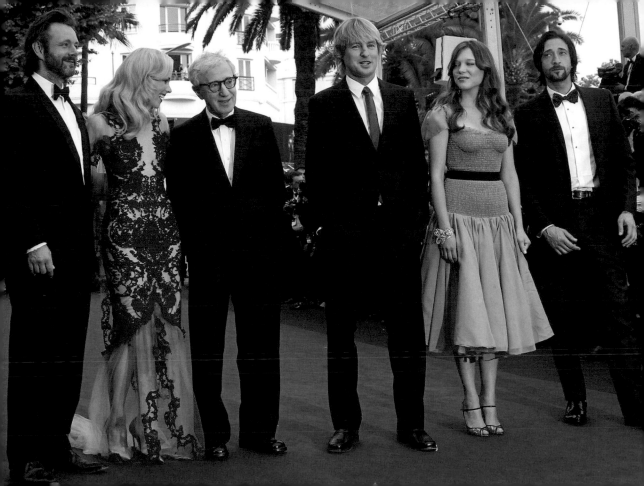

"On the plus side, death is one of the few things that can be done just as easily lying down."
—WOODY ALLEN

The budgets on Allen's films are usually a fraction of what it costs to make other motion pictures. This being the case, most actors on his projects are paid scale, or what amounts to the minimum wage allowable by the Screen Actors Guild. Even big-name actors take far less than their normal salary simply for the chance to work with Woody.

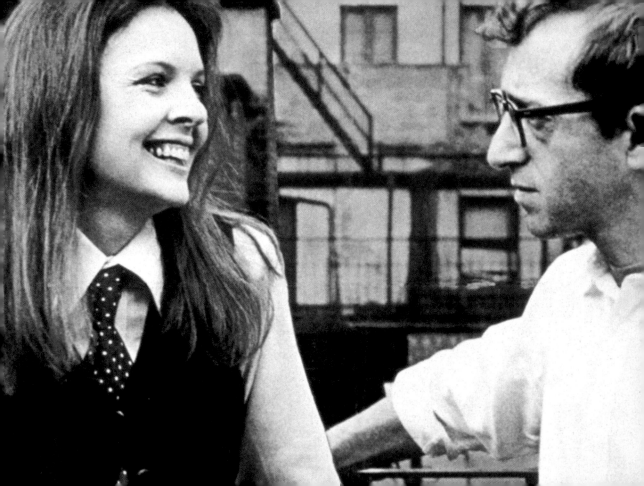

"It was his manner that got me, his way of gesturing,
his hands, his coughing and looking down in a self-deprecating
way while he told jokes like 'I couldn't get a date for
New Year's Eve so I went home and I jumped naked
into a vat of Roosevelt dimes.'"
—DIANE KEATON

"It has lived up to every hope, dream, and expectation. He's just as wonderful and as funny and self-deprecating as you would expect him to be."
—ARI GRAYNOR, ACTRESS IN ALLEN'S PLAY *HONEYMOON HOTEL*

"I've worked with a million people over the years and they've all been really wonderful. That's been my secret of directing actors: hire wonderful people and take credit for their work."
—WOODY ALLEN

In keeping with his quiet persona and less-is-more directing style, Allen refuses to provide commentary tracks on the DVD versions of his movies. He has stated on more than one occasion that he hopes his films speak for themselves.

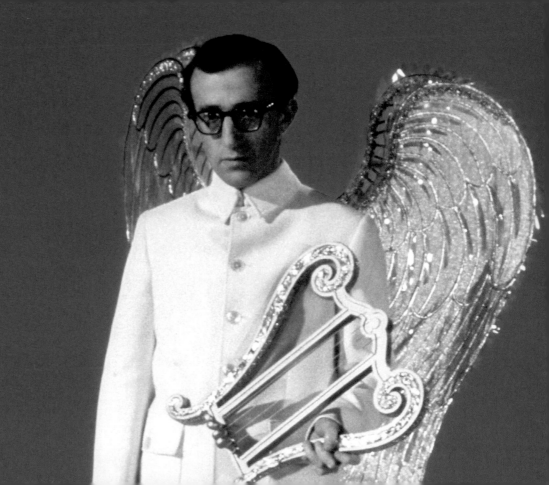

"I don't believe in an afterlife, although I'm bringing along a change of underwear."
—WOODY ALLEN

In 2011, Allen's romantic fantasy *Midnight in Paris* hit theaters. He had actually come up with the title for this project before he knew what the story was going to be about. The film went on to gross over $100 million worldwide, becoming the most commercially successful Woody Allen movie ever.

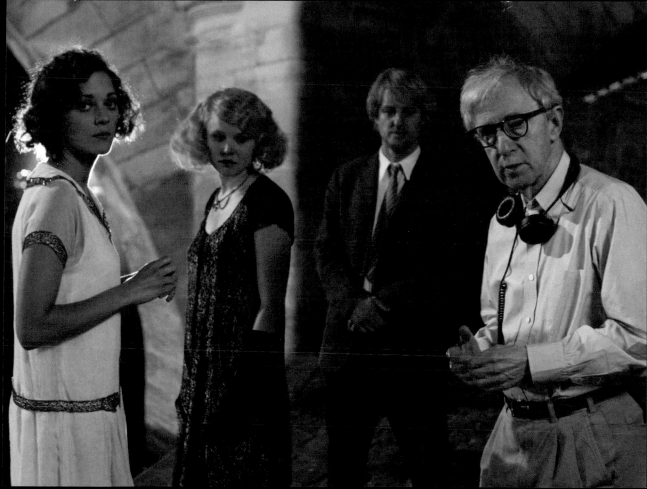

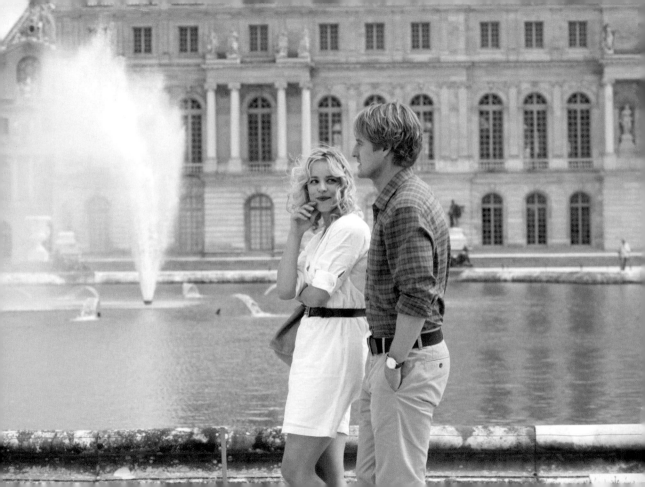

"For some reason I'm more appreciated in France than I am back home. The subtitles must be incredibly good."
—Woody Allen

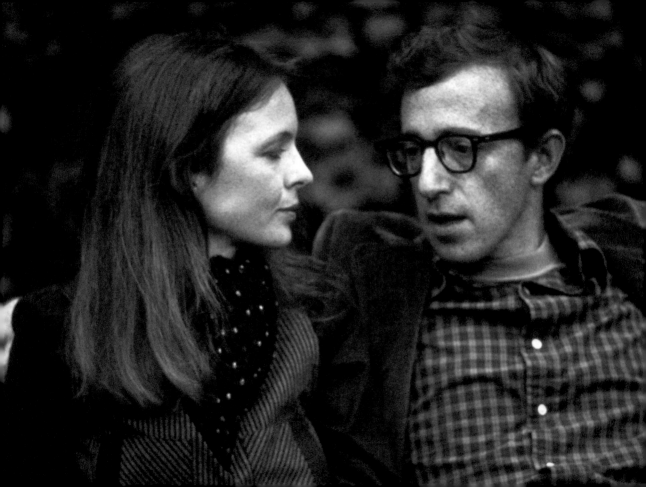

"We shared a love of torturing each other with our failures. His insights into my character were dead-on and hilarious. This bond remains the core of our friendship and, for me, love."
—Diane Keaton

"I don't want to achieve immortality through my work.
I want to achieve it by not dying."
—Woody Allen

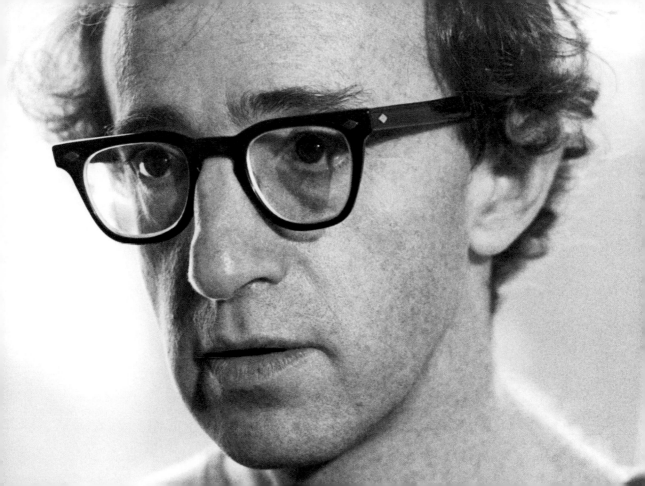

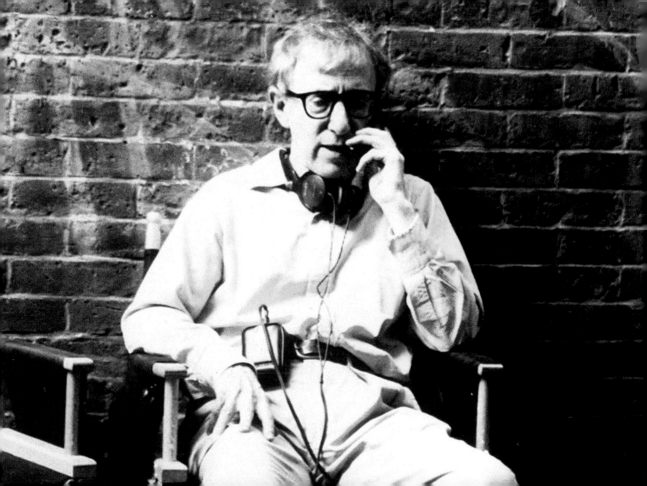